How to Draw VIDEO GAMES

Create unique characters, worlds, levels and more!

STEVE HARPSTER

IMPACT
CINCINNATI, OHIO
impact-books.com

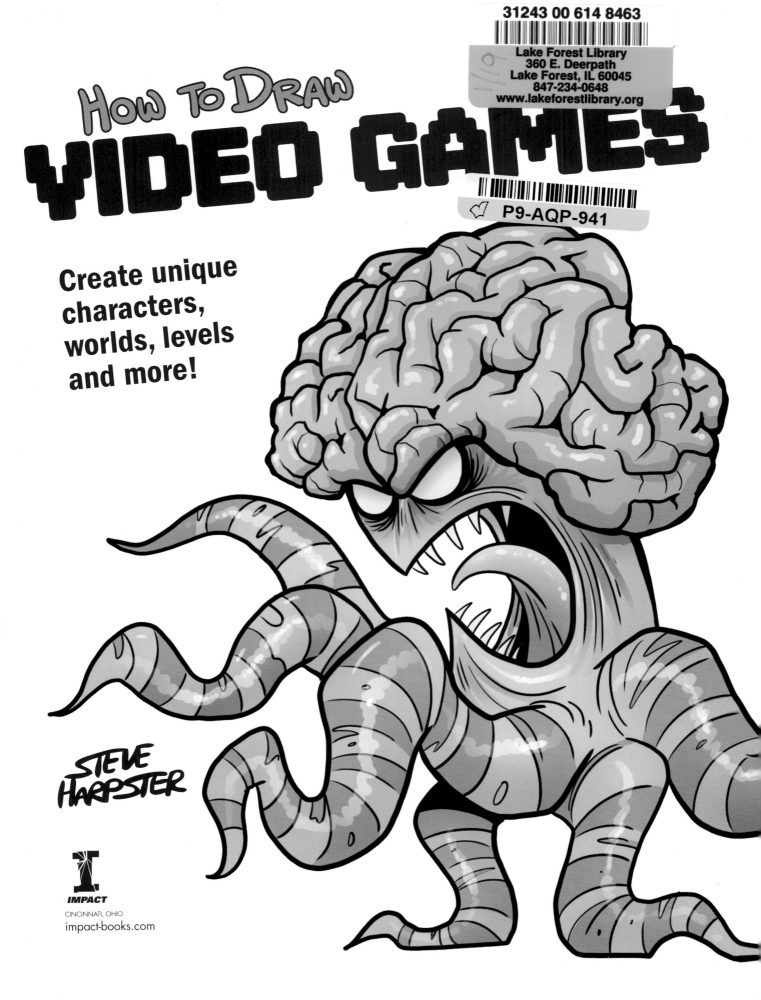

Contents

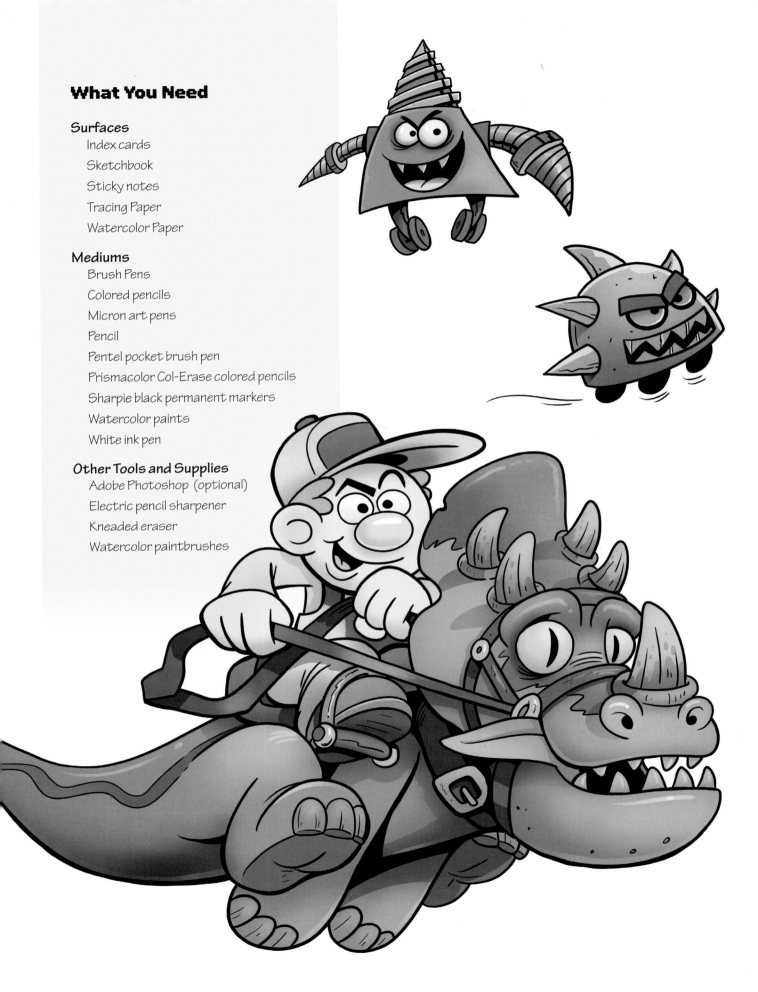

What You Need

Surfaces
Index cards
Sketchbook
Sticky notes
Tracing Paper
Watercolor Paper

Mediums
Brush Pens
Colored pencils
Micron art pens
Pencil
Pentel pocket brush pen
Prismacolor Col-Erase colored pencils
Sharpie black permanent markers
Watercolor paints
White ink pen

Other Tools and Supplies
Adobe Photoshop (optional)
Electric pencil sharpener
Kneaded eraser
Watercolor paintbrushes

Hey drawing fans,

If you picked up this book you must like video games, but it is my hope to make it just as fun to create video games as it is to play them. Let's face it, there are huge differences between drawing and video games. A video game is easy to pick up and play while drawing Well, wait a minute . . . Drawing is something you just pick up and play, too! Okay, well, in video games the more you play and increase levels, the harder it gets, but drawing Oh, nope, another bad example. Drawing also gets harder the more you increase your skill levels. So how is a video game different from drawing? I know! There is no high score when it comes to drawing. But wait, if there's no score then how do we know if we are good at drawing or not? When you're drawing you don't get one-ups or bonus points or even a chance to save your initials in the high scores. How do we know who is and who is not good at drawing? Unfortunately too many people decide they are not good at drawing and give up on it. So give me a chance to help you with your drawing skills. The goal of this book is not only to make you a better artist, but to help you get those ideas from inside your head and onto that piece of paper. And I think I have some helpful and clever tricks for that. So grab your pencil and your paper and let's draw!

STEVE HARPSTER

Your drawing quest is about to begin. The goal of this book is to teach you skills and tricks to make you a more confident artist.

You will learn how to create amazing new worlds and difficult levels to play and solve.

You will not only learn to draw the characters in this book, but you will also learn the skills to create your own awesome characters.

This book will inspire ideas and motivate you to draw and create.

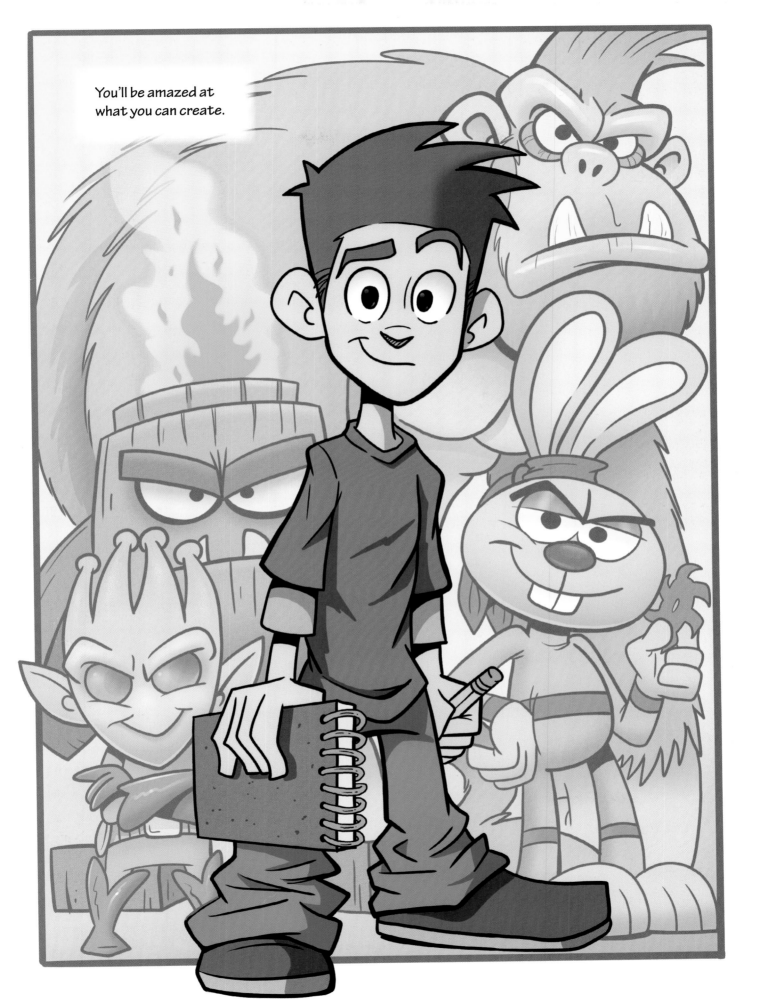

You'll be amazed at what you can create.

Materials

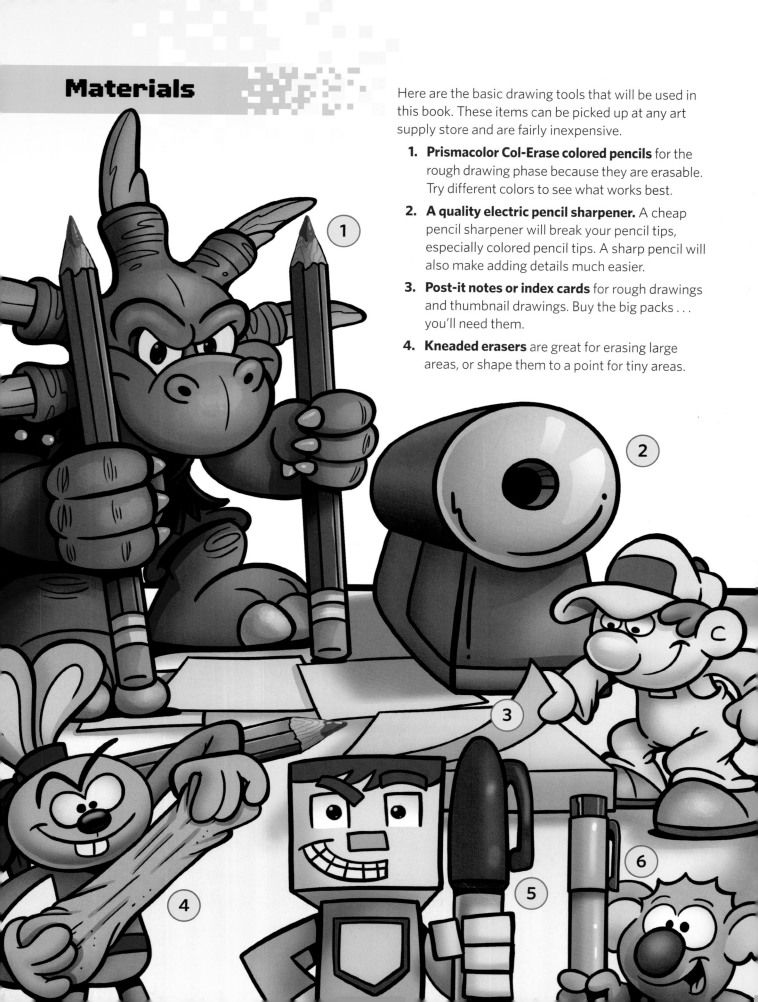

Here are the basic drawing tools that will be used in this book. These items can be picked up at any art supply store and are fairly inexpensive.

1. **Prismacolor Col-Erase colored pencils** for the rough drawing phase because they are erasable. Try different colors to see what works best.

2. **A quality electric pencil sharpener.** A cheap pencil sharpener will break your pencil tips, especially colored pencil tips. A sharp pencil will also make adding details much easier.

3. **Post-it notes or index cards** for rough drawings and thumbnail drawings. Buy the big packs . . . you'll need them.

4. **Kneaded erasers** are great for erasing large areas, or shape them to a point for tiny areas.

5. **Sharpie markers** are perfect for thick lines and blocking in large areas of black. Plus, they are cheap to purchase by the box.

6. **Micron art pens** are great for fine lines and come in a variety of sizes. Try using different sizes for different line effects.

7. **Sketchbooks** are a must. There are many kinds of sketchbooks with different types and sizes of paper. Try out different sketchbooks and see what you like best.

8. **Traditional colored pencils** are an easy way to quickly add color to your characters. They offer a wide range of colors and they can be blended to create a variety of effects.

9. **Brush pens** are a great way to quickly get thin and thick lines with one stroke. These pens are not easy to use at first. With some patience and lots of practice, a brush pen can take your drawings to the next level. I love the Pentel pocket brush pen.

10. **A white ink pen** can create really cool highlights and also cover up mistakes. I have tried many different versions, but the one I like the best is the Gelly Roll white ink pen.

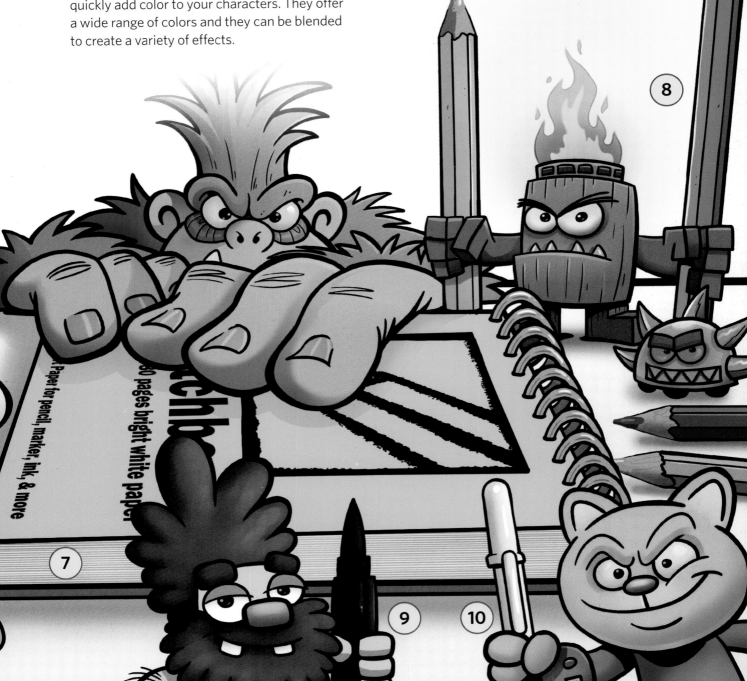
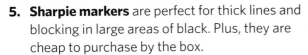

Warm-up Exercise

Rough Ideas

In this book we will be using sticky notes or index cards to create the initial rough ideas for the characters, vehicles and worlds.

Sharpies

I like to create ideas with Sharpies because they're inexpensive and you can't erase. You're forced to not make perfect drawings.

No Eraser

If you don't like an idea, crumple it up and throw it away!

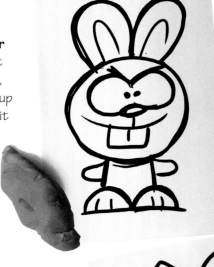

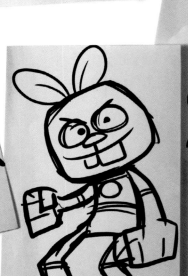

Keep It Fun and Loose

Start sketching some characters of your own. The point of this exercise is to come up with a lot of ideas for a lot of characters. Think about different body shapes, interesting looks and fun styles. The key word is *fun*, no pressure to make perfect art.

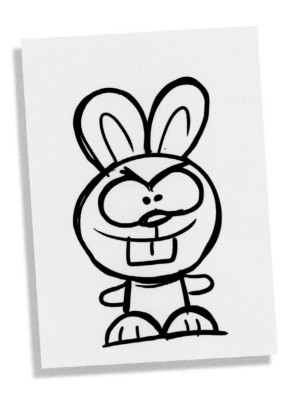

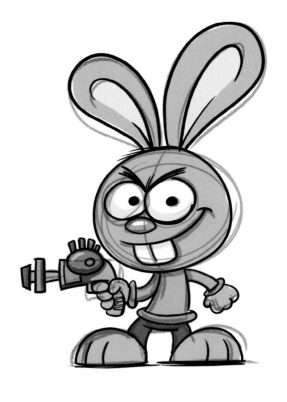

From Rough to, um . . . Less Rough?

Now take the best ideas from the very rough drawings you created and draw them again. This is the time when you can try adding details such as costumes and different expressions. Have fun with this step and see what kinds of quirky and interesting characters you create. It's so amazing to see what a simple little doodle can turn into.

1 A HERO IS BORN

The Hero of the Game

In this first chapter we will create the hero for our video game idea. Video game heroes come in all shapes and sizes. From humans trying to save the Earth to aliens trying to save the galaxy, heroes are an important part of making a video game more than just a game. The hero adds a story for the player to follow and understand. The hero can be a brave warrior ready for battle or a weak little wimp with little to no hope of saving the day. Get ready to create the most important character of the game, the hero.

Chicken Scratch?

Keeping Your Character Ideas Loose and Fun

In this chapter you're going to see me use sticky notes, index cards and scraps of paper to create rough doodles or ideas for my characters. I am going to show you how to draw various characters, but my real goal is to show you the process I used for coming up with a rough character and then breaking it down into simple steps so I could easily draw it again and again in different poses. I started with a simple chicken character. Our chicken is the hero, but this is not a brave warrior of a hero—it's a chicken.

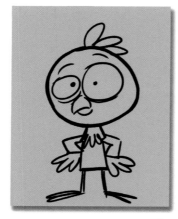
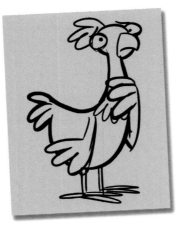

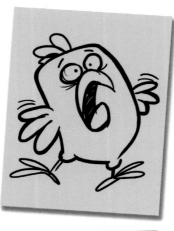
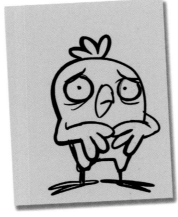
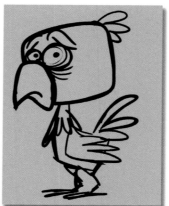

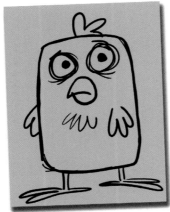

After creating several rough ideas for the chicken character, I stumbled upon this one. When I broke this character down into easy-to-draw shapes, I saw a marshmallow with eyes and wings.

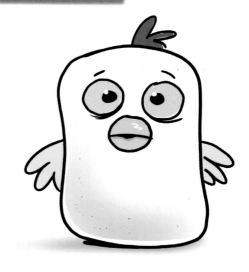

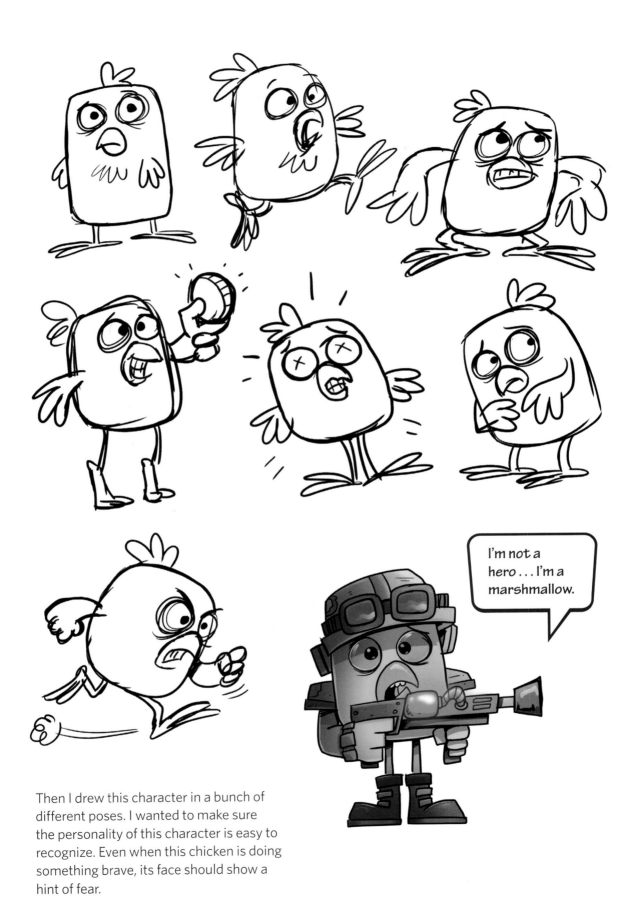

I'm not a hero...I'm a marshmallow.

Then I drew this character in a bunch of different poses. I wanted to make sure the personality of this character is easy to recognize. Even when this chicken is doing something brave, its face should show a hint of fear.

Bad Guy or Good Guy?

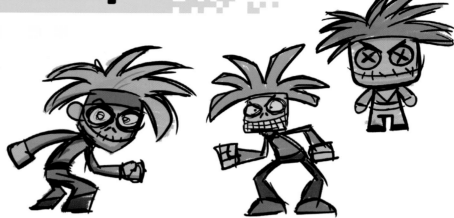

Maybe the hero of the game is closer to a bad guy than a good guy. What if the hero does terrible things to defeat the enemies? Here I'll show you how to create a character brought back from the dead to bring villains to justice.

1 Start thumbnailing ideas for the creepy crusader. I was going for a half zombie and half voodoo doll look. Color is going to play a big part in the design of this character, so I threw some color ideas into the thumbnails.

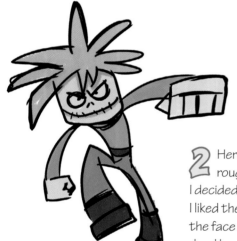

2 Here is the rough thumbnail I decided to go with. I liked the pose and the face of this living dead hero.

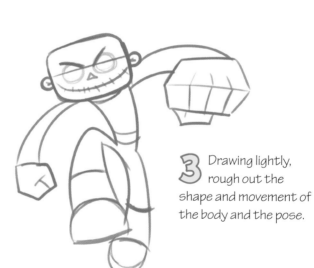

3 Drawing lightly, rough out the shape and movement of the body and the pose.

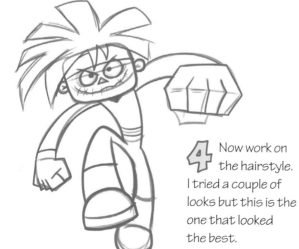

4 Now work on the hairstyle. I tried a couple of looks but this is the one that looked the best.

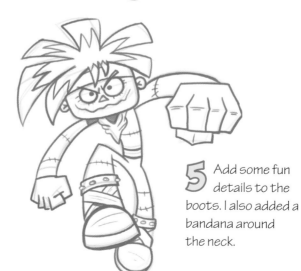

5 Add some fun details to the boots. I also added a bandana around the neck.

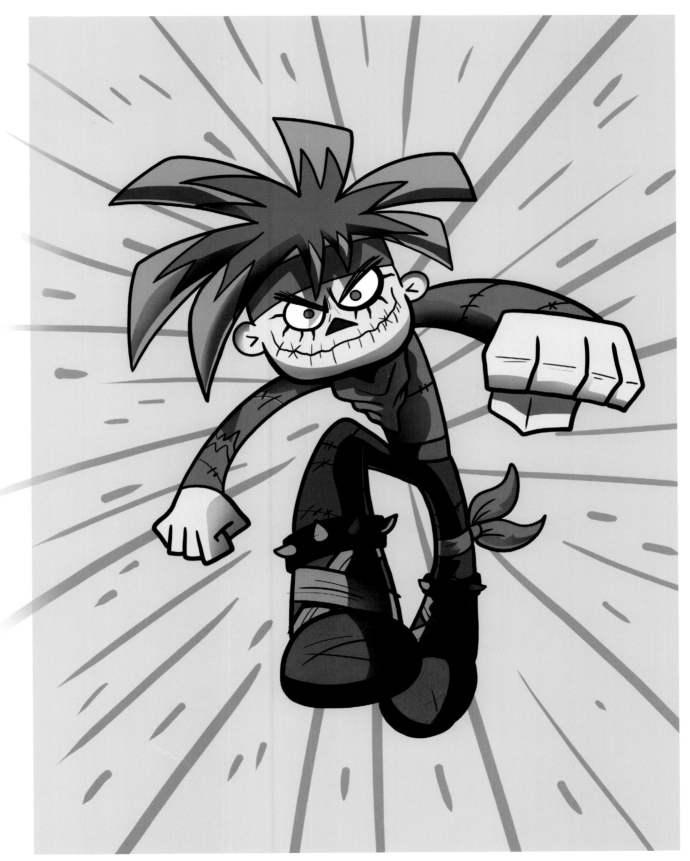

Even as I inked and colored the final drawing, I made changes to the character. I added spikes to the boots and another bandana to the leg. I decided to make the pupil of the eyes red and added thick black lines around the eyes for an even creepier look.

Painter Pete

All the colors in the world are being sucked off the face of the Earth by evil color-stealing clowns. Only one person with a magic paintbrush can thwart these color thieves from ending the world as we know it.

1 Draw a circle for Painter Pete's head and another diagonal shape below the head for his little body.

2 The lines across the circle tell me where the face should go and I can also add the lines for the ear.

3 Now add the shapes for the legs, feet and arms. Work on the mouth and eyebrows to create expression for this tiny hero.

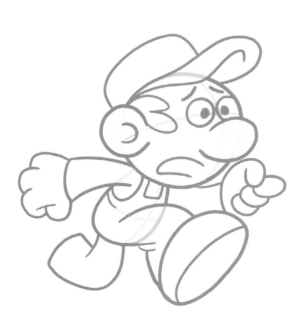

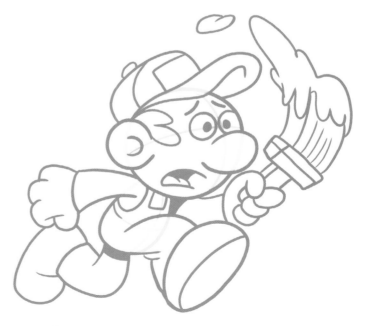

4 Draw a painter's cap for the top of the head and some cartoon-style hands. One hand will be holding a paintbrush.

5 Add the paintbrush to the drawing. As I drew this character I thought about his personality. What are his strengths and weaknesses? What is his story and what are his powers?

Splat the Puppy

Splat is Painter Pete's loyal pup and very useful sidekick. When Painter Pete is running low on paint or might need an extra life to solve a level, Splat is there to lend a paw. What other tricks does this pooch know?

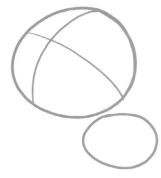

1 Draw two circle shapes for the start of this painted puppy.

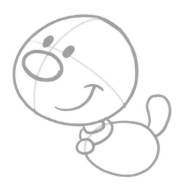

2 Draw a simple face to this pooch. Add a neck with a collar to connect the head to the body. Then draw a small tail.

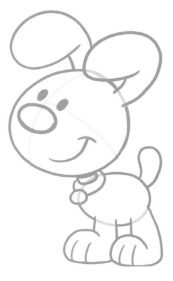

3 Add legs and feet to this playful pup. I chose to create my puppy's ears sitting on top of the head, but you can make floppy or pointed ears if you like.

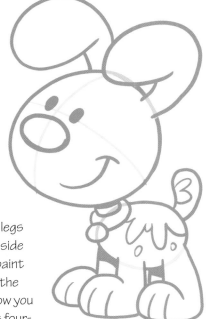

4 Now add the legs on the other side of the body and a paint splatter or two to the back of the dog. Now you have Painter Pete's four-legged sidekick!

Zumona Saves Her Planet

A giant planet-eating space slug is threatening peaceful worlds all over the galaxy. It is up to Zumona to save her planet and others from this humongous world muncher. She must fly into the beast's belly on her surf rocket and destroy the creature from the inside out.

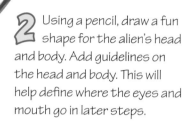

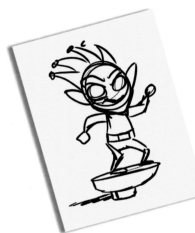

1 Start out on sticky notes with a rough concept for an alien character riding some type of space surfboard.

2 Using a pencil, draw a fun shape for the alien's head and body. Add guidelines on the head and body. This will help define where the eyes and mouth go in later steps.

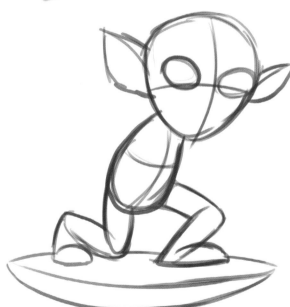

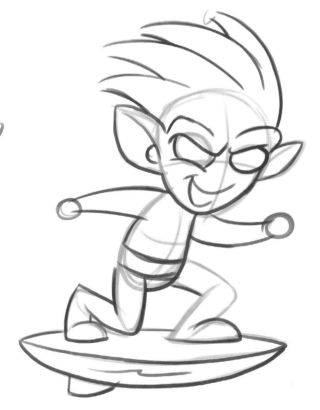

3 Figure out the placement of the eyes and ears using the guidelines on the head shape. Work on the placement of the legs on the surf rocket. Try to give a sense of movement and balance by bending the legs at the knees.

4 I wanted the hair to look like squid tentacles. Maybe this character can stick to ceilings using her hair. Work on the position of the arms, keeping in mind the idea of portraying action as she glides through space.

5 Add details to Zumona's tentacle-like hair. Add hands, fingers and more details to the surf rocket and belt.

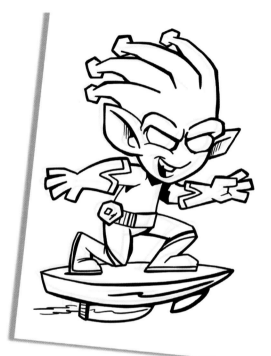

Inking

Even when I draw the final character in ink, I might do a second inking where I try a different style or slightly change the look of the character or the clothing. Here I gave Zumona's gloves and boots a different style.

Zumona is ready to take on that giant space slug now as she zips through the galaxy on her surf rocket.

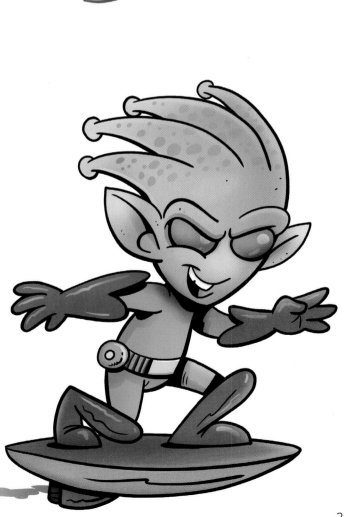

The Ninja Bunny

Cute little bunny by day and a crime-fighting ninja at night. With adventure and kick-butt, carrot-eating action, this rabbit hero is always on the move.

1 Draw an egg shape for the head and a bean shape for the body. Add some construction lines so you know where to place the facial features.

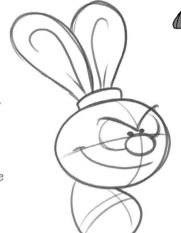

2 Sketch in the face and the placement of the ears. This is all very rough and loose. It's not supposed to be perfect yet.

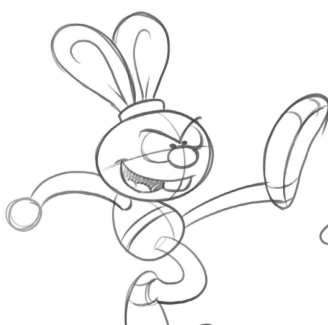

3 Keeping everything loose, add more details to the mouth. Then start working on the placement for one of the arms and the legs.

4 Keep making changes to your character in the rough sketch stage. I wanted the ears to flow with the body's movement, so I erased and changed them. I changed the mouth from open to closed. I also added the arm on the other side of the body.

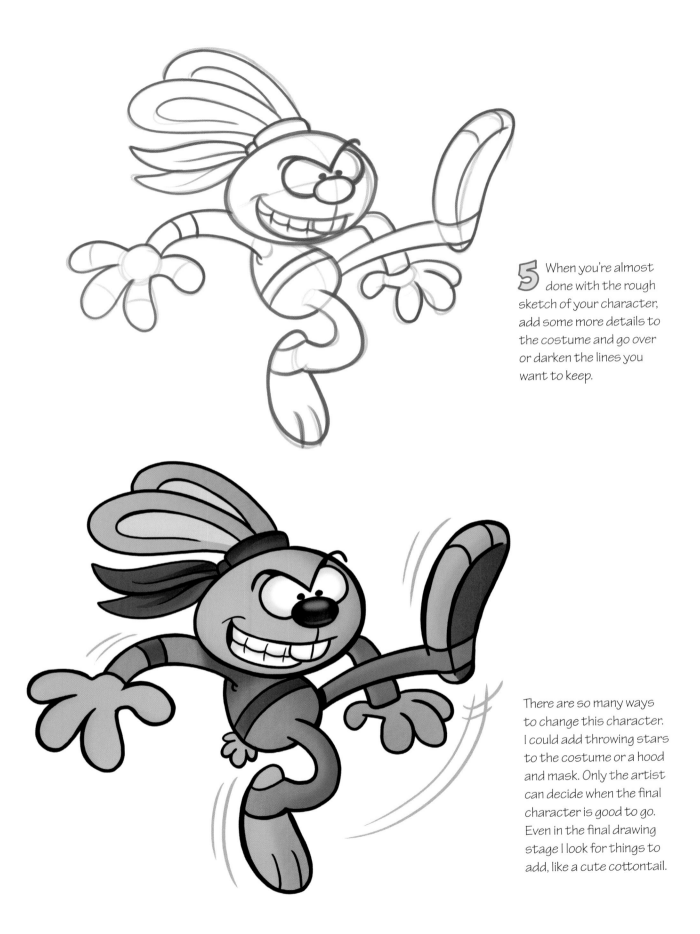

5 When you're almost done with the rough sketch of your character, add some more details to the costume and go over or darken the lines you want to keep.

There are so many ways to change this character. I could add throwing stars to the costume or a hood and mask. Only the artist can decide when the final character is good to go. Even in the final drawing stage I look for things to add, like a cute cottontail.

Space Marine

Armed to the T with a variety of weapons and protected by a full body suit of heavy mechanized armor, this space marine is ready to take on enemies of all forms and on all kinds of terrain.

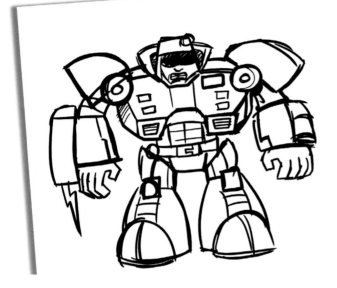

1 Drawing complex characters like this space marine is never easy. Start with a rough thumbnail drawing on an index card. Then make the thumbnail drawing much bigger by using a photocopier or a computer program like Adobe Photoshop.

2 I noticed my character is looking too squatty, so I simply tore the character in half. I placed another sheet of paper on top and redrew the top half using the rough drawing as a basic guide. Do the same thing with the bottom portion, taking care to draw a longer torso.

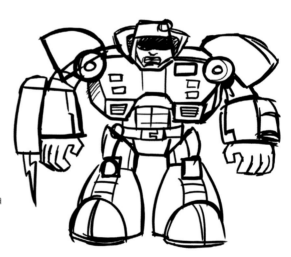

3 Then I had a good template for creating some butt-kicking space warriors. This character is going to need some amazing armor to withstand the evil alien armies and hostile planet terrains he will be facing.

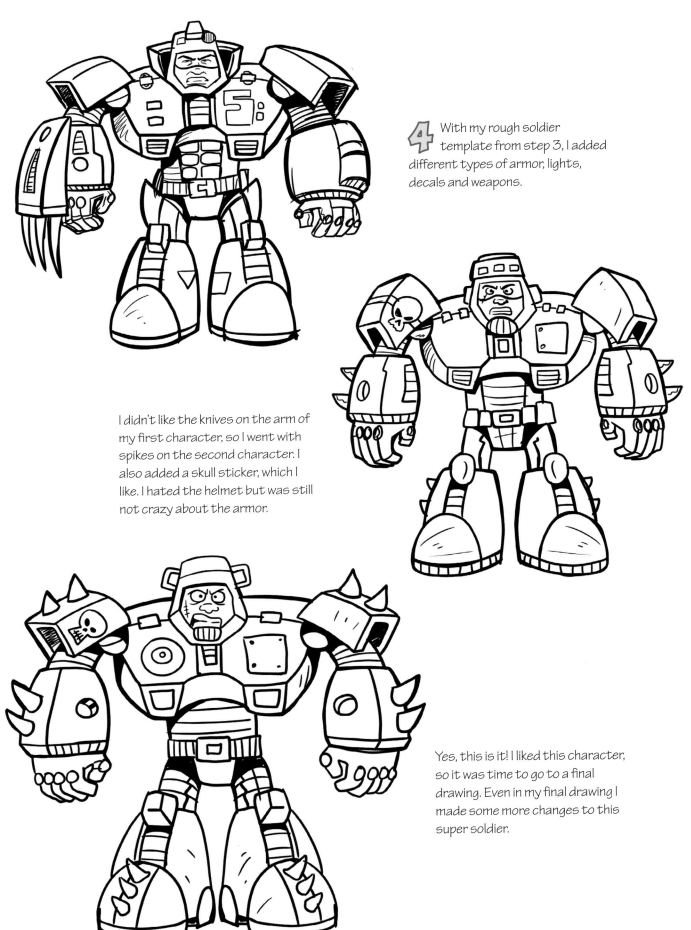

4 With my rough soldier template from step 3, I added different types of armor, lights, decals and weapons.

I didn't like the knives on the arm of my first character, so I went with spikes on the second character. I also added a skull sticker, which I like. I hated the helmet but was still not crazy about the armor.

Yes, this is it! I liked this character, so it was time to go to a final drawing. Even in my final drawing I made some more changes to this super soldier.

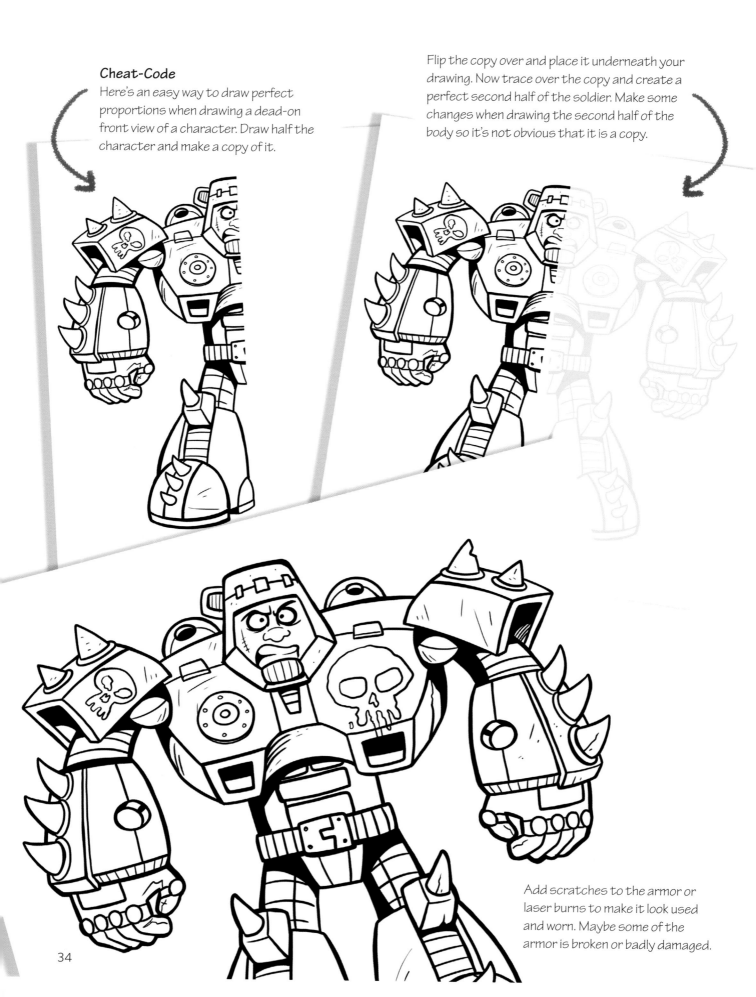

Cheat-Code
Here's an easy way to draw perfect proportions when drawing a dead-on front view of a character. Draw half the character and make a copy of it.

Flip the copy over and place it underneath your drawing. Now trace over the copy and create a perfect second half of the soldier. Make some changes when drawing the second half of the body so it's not obvious that it is a copy.

Add scratches to the armor or laser burns to make it look used and worn. Maybe some of the armor is broken or badly damaged.

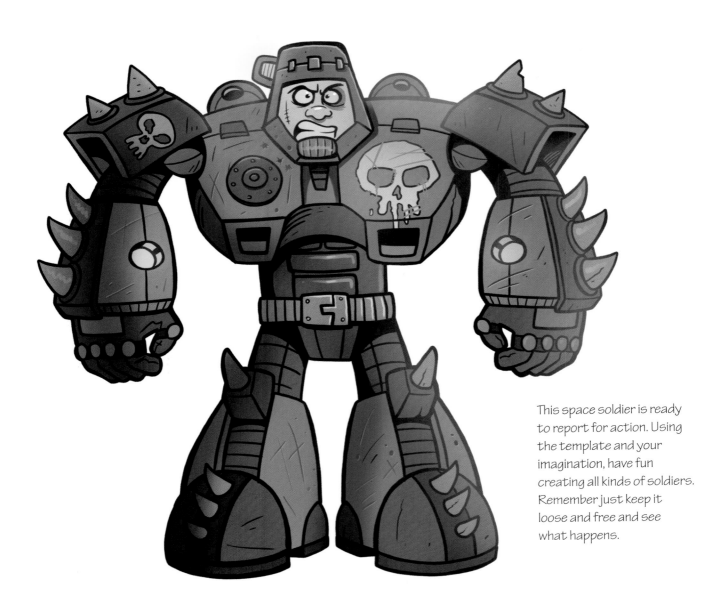

This space soldier is ready to report for action. Using the template and your imagination, have fun creating all kinds of soldiers. Remember just keep it loose and free and see what happens.

Hang in there soldier . . . We have a lot more drawing to do because next we draw . . .

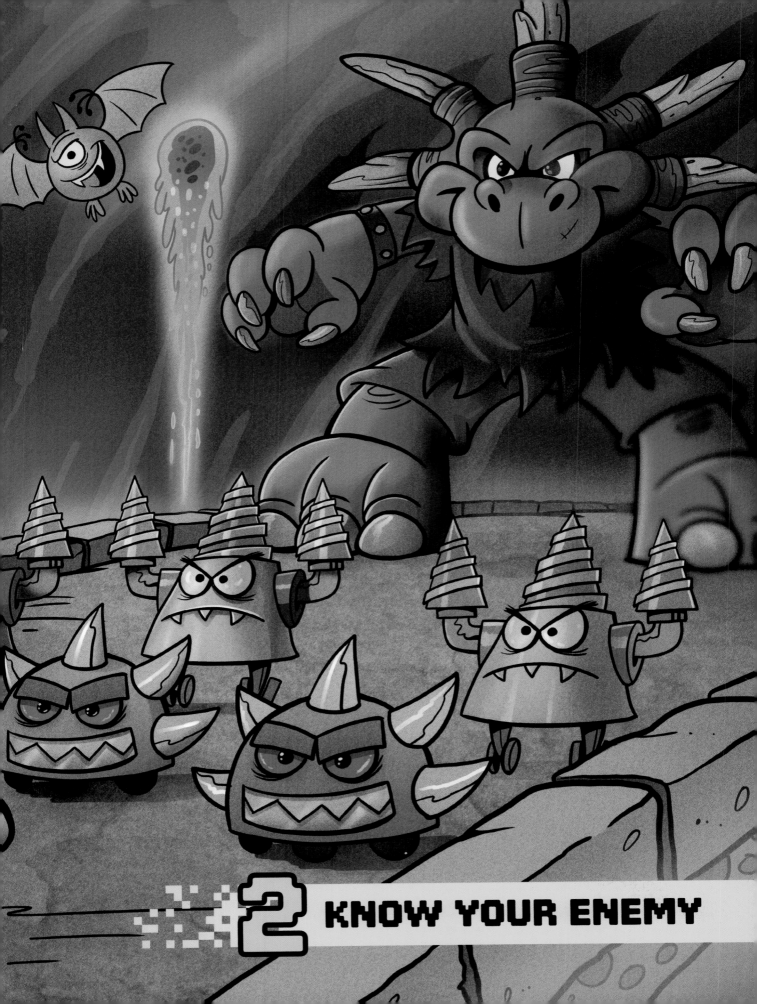

2 KNOW YOUR ENEMY

Starting Basic

The importance of starting a drawing with basic shapes cannot be overstated. In this exercise you'll notice how these very simple shapes can easily be turned into complicated looking characters.

Semicircle

 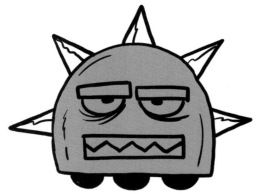

1 Draw a half circle or semicircle.

2 Add the face and the teeth. Feel free to create a different face than the one here.

3 Add the sharp spikes and wheels.

Square

 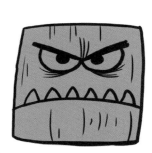 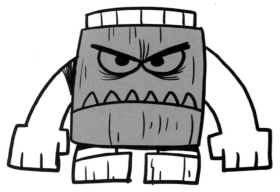

1 Draw square shape with rounded corners.

2 Create a face for your character.

3 Now add the arms and the legs. Add texture to make it look wooden.

4 Now draw a flame coming off the head. An easy character to draw, but not easy to defeat.

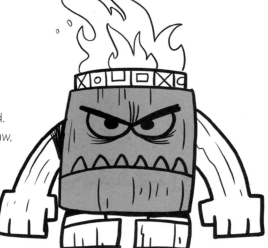

Triangle

1 This time we'll create a character from a triangle.

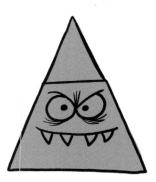

2 Add a creepy face to this enemy.

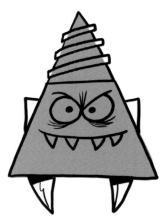

3 I decided to make the top of the head a drill. I repeated the triangle shape over and over.

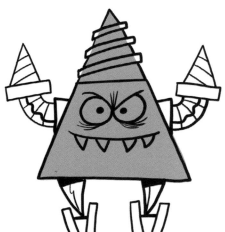

4 Last, I added wheels, arms and two more drills for hands to this triangle of terror.

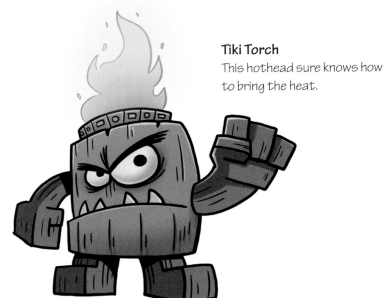

Tiki Torch
This hothead sure knows how to bring the heat.

Rolling Spike Mine
This enemy rolls into you and it's game over.

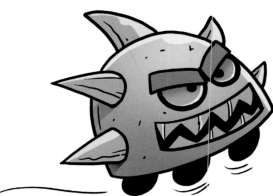

Drill Bit
Watch out for this sharp fellow; he gets straight to the point.

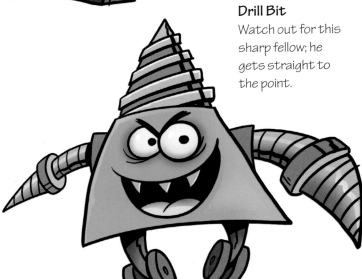

Shape-Shifting Bad Guys

Here I used very simple shapes to create bad guys. See how many characters you can create with these simple shapes and be sure to rearrange the shapes to invent an even larger inventory of bad guys for your game. Drawing them is easier than coming up with the names for them.

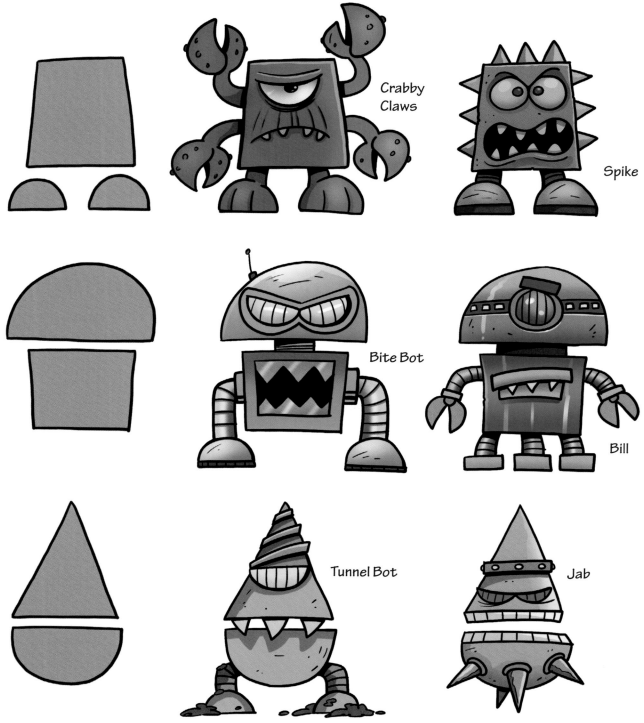

Crabby Claws

Spike

Bite Bot

Bill

Tunnel Bot

Jab

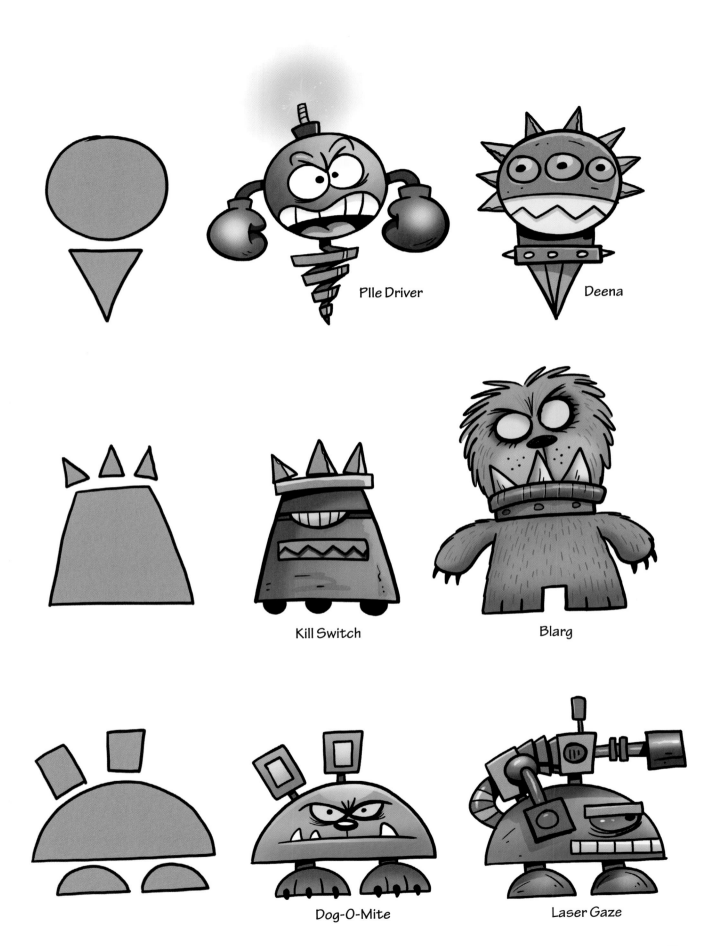

Plle Driver

Deena

Kill Switch

Blarg

Dog-O-Mite

Laser Gaze

Generating Ideas for Enemies

The absolute number one question I am asked is "How do you come up with ideas for what to draw?" Here is one of my best tricks for creating characters. Start by drawing the silhouette or the shadow of the character first. Create interesting forms and shapes with a gray marker. Here I am using Photoshop to paint some interesting shapes and forms.

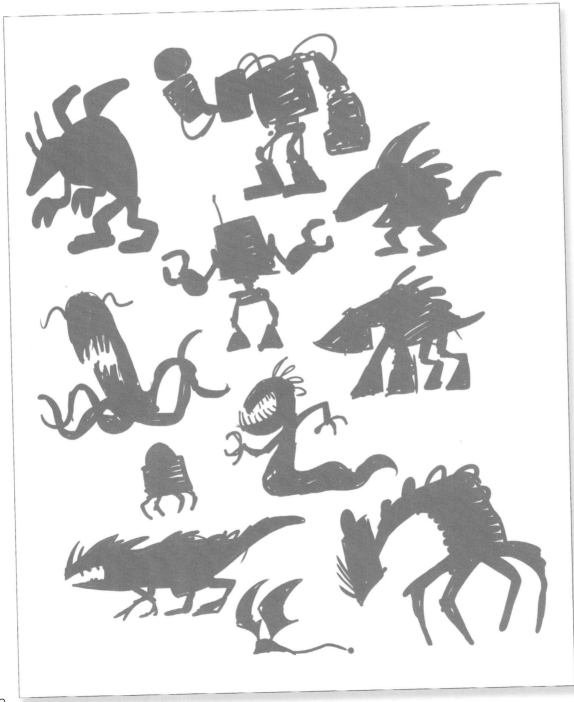

No need to finish the drawings. They
are used only to help generate ideas.

Don't stick to the original
gray silhouette if you don't like
it. Feel free to not use parts
of it or to create outside of it.

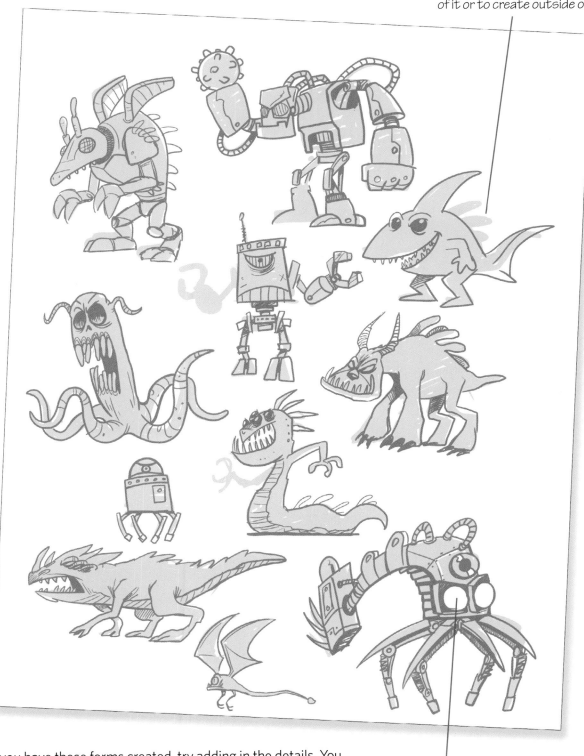

Once you have these forms created, try adding in the details. You
can do this with a black pen on top of your marker sketches. In
this example I used a dark gray color to sketch in ideas on a new
layer using Photoshop on my computer.

Here I added white
for the eyes.

After looking over my rough ideas, I decided to use this robot for one of my enemies in the game.

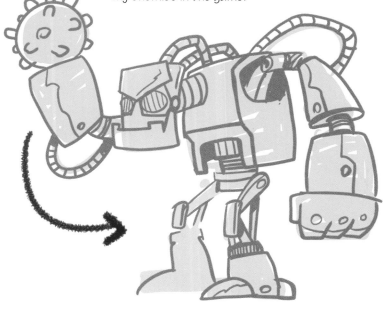

I hated the placement of the arm, so this is the first thing I adjusted.

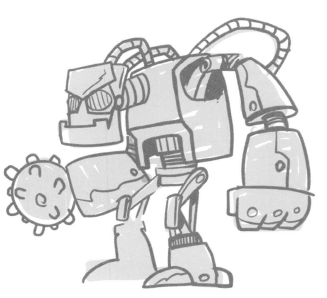

Not only did the arm need to be moved, but it is not in the correct perspective, so I went over this rough drawing again and created the correct perspective for the robot's arm.

Using tracing paper I tried different looks for the head of this metal monster until I created one I liked.

Now that I had the correct perspective, I wondered if I had the best choice for the robot hand. So I created other options for this mighty-metal warrior.

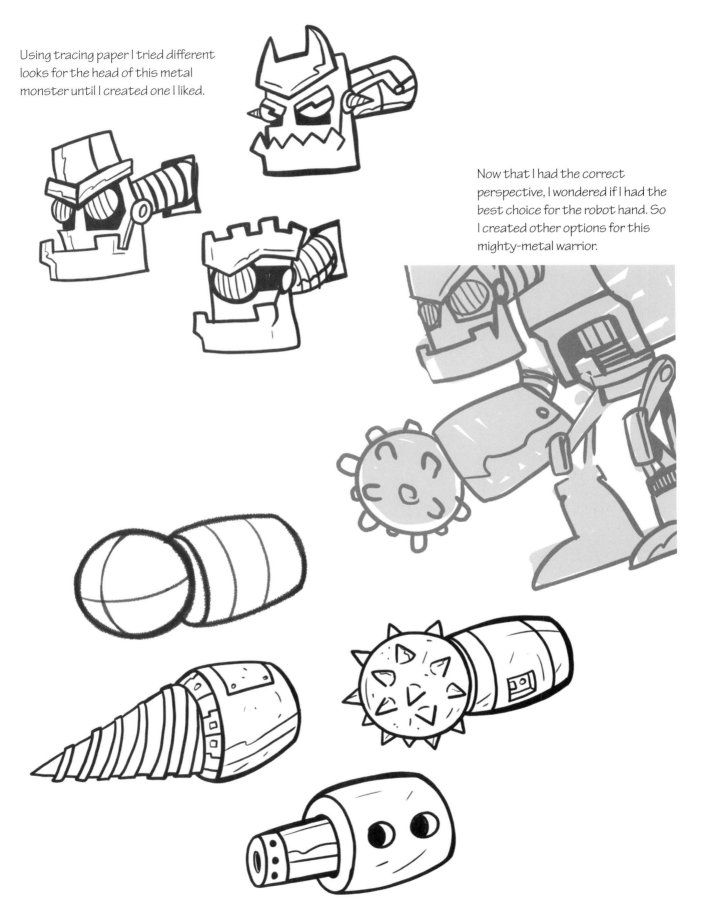

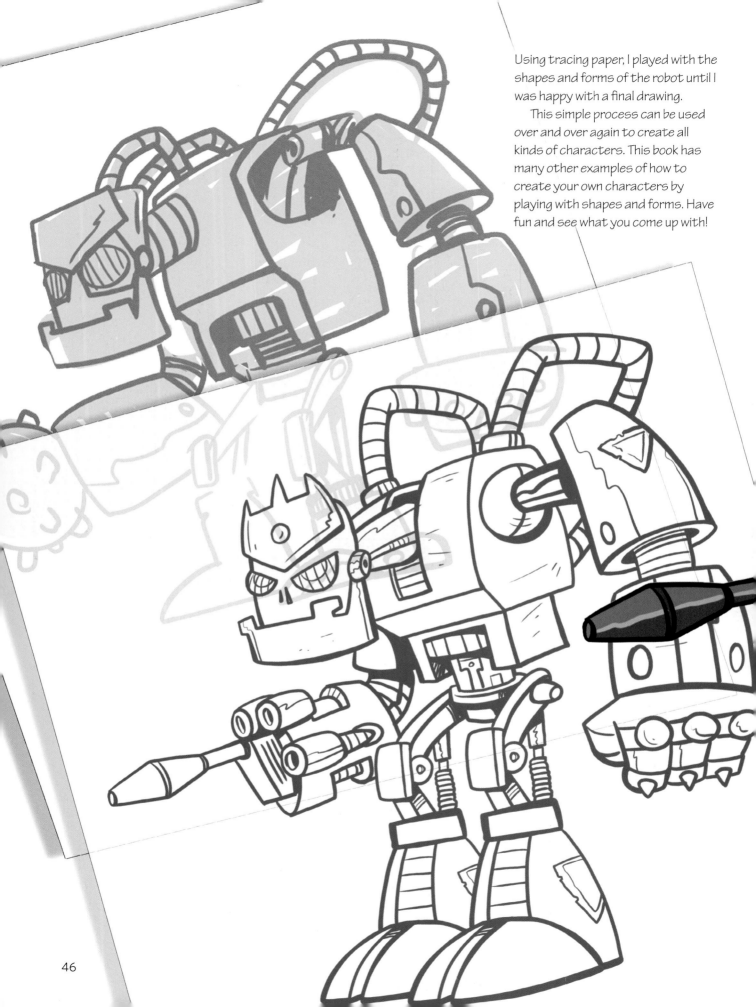

Using tracing paper, I played with the shapes and forms of the robot until I was happy with a final drawing.

This simple process can be used over and over again to create all kinds of characters. This book has many other examples of how to create your own characters by playing with shapes and forms. Have fun and see what you come up with!

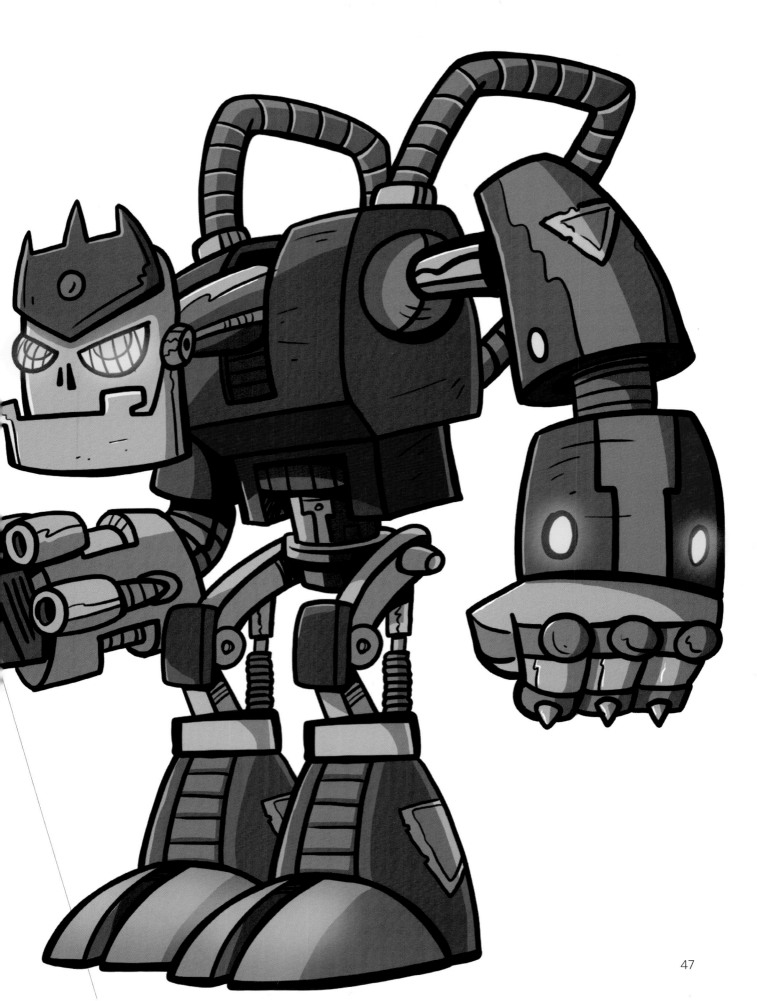

Evil Crab

Using shadows or random shapes works when you have no idea what your character should look like, but what if you have a specific type of character you want to draw? Let's say you know your character is going to be an evil crab monster with claws. This character is going to be used in an underwater level, or something to do with the ocean.

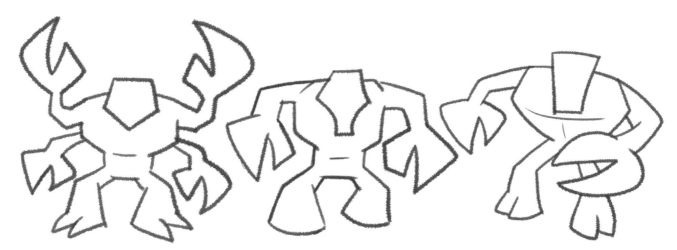

1 Instead of working with random shapes we are going to work with an outline, or a contour drawing, of our character. By doing this we can see right away what works and doesn't work for our game character.

2 Once you decide on the best outline or body for the character, begin drawing lines over the top of it. Make copies of your original or use a sheet of tracing paper.

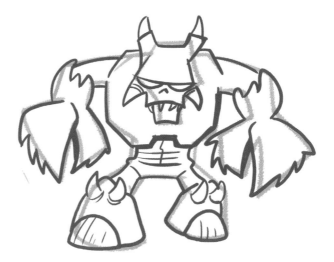

Rough Idea 1
This is where the fun happens. Play around with different faces, horns and body armor. How far can you push this character?

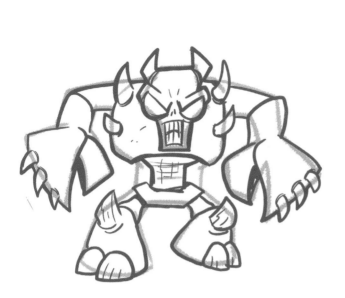

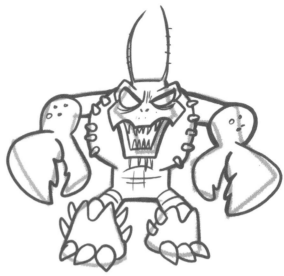

Rough Idea 2

There are things I liked and didn't like about each of the three rough characters I created.

Rough Idea 3

I took all the good parts that I liked from the rough drawings and used them to create my final drawing.

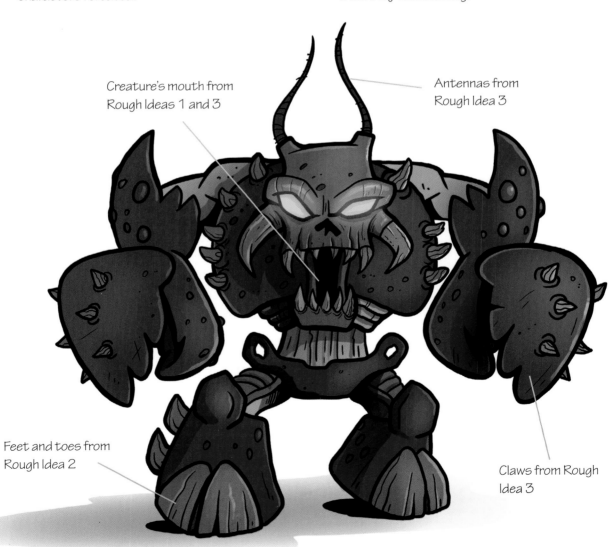

Creature's mouth from Rough Ideas 1 and 3

Antennas from Rough Idea 3

Feet and toes from Rough Idea 2

Claws from Rough Idea 3

Evil Skeleton Warriors

In this example the shape, size and form of the body is already defined. This game calls for a variety of looks for some evil skeleton warriors. It is easy to create different armor and looks for the skeleton warriors by drawing over the top of the body template shown here.

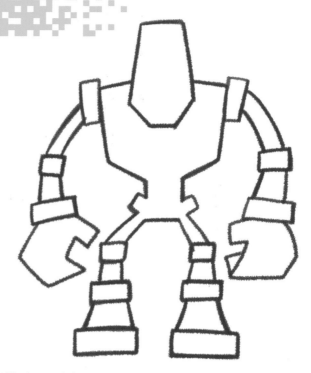

Skeleton Warrior

Small changes to the skeleton's armor make each warrior look completely different. As you create your warriors think about how they came to be. Were they once proud knights cursed by a witch's spell, or are they searching the earth for a final resting place?

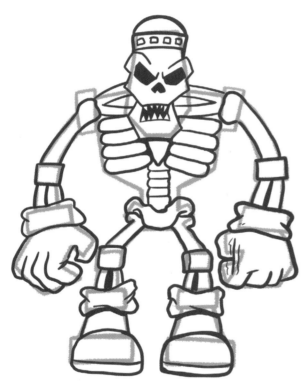

Skeleton Foot Soldier

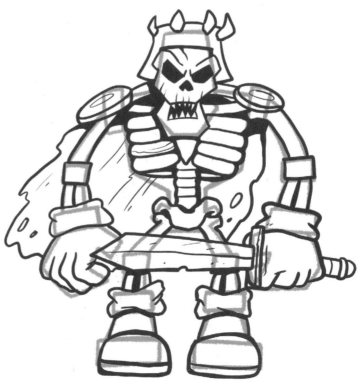

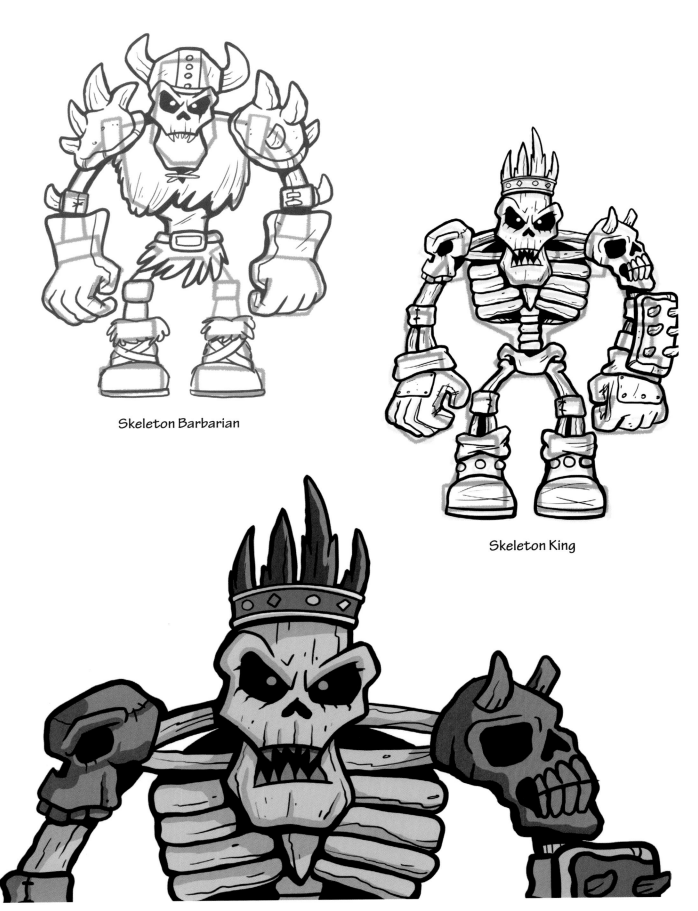

Skeleton Barbarian

Skeleton King

Monkey Bash

This grape ape can crush you like a rotten banana in his giant hands. He can swing through the jungle on vines or climb to the top of a skyscraper with ease. One thing for sure, this gorilla is ready for battle.

I drew rounded construction lines so I could understand the form of my character's arms, legs and torso.

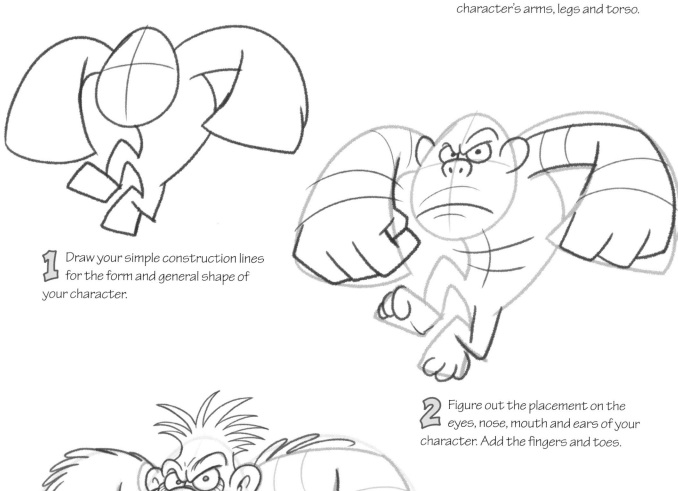

1 Draw your simple construction lines for the form and general shape of your character.

2 Figure out the placement on the eyes, nose, mouth and ears of your character. Add the fingers and toes.

3 Now add more details to your character such as teeth and hair. Don't be afraid to stray from the original construction lines.

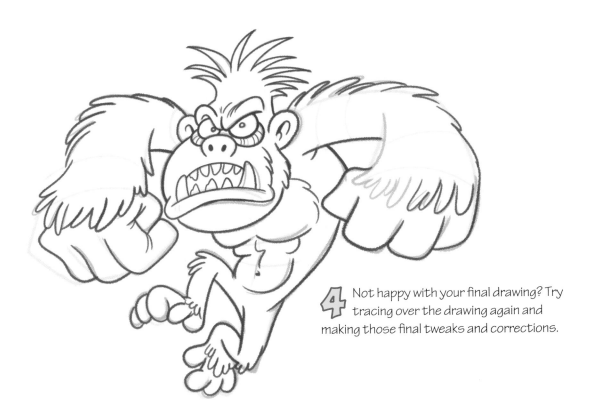

4 Not happy with your final drawing? Try tracing over the drawing again and making those final tweaks and corrections.

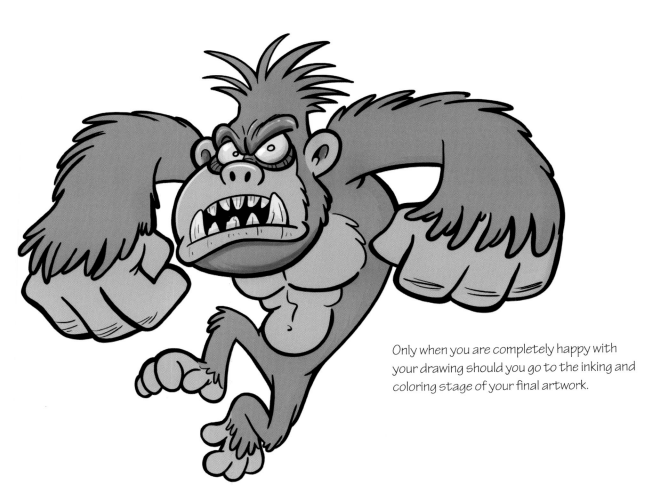

Only when you are completely happy with your drawing should you go to the inking and coloring stage of your final artwork.

Grunk

This horned villain lives in hot lava caves. He can throw fireballs and tantrums. You have to be fast on your feet to get past this hotheaded clown!

1 Draw a circle for the head and then another rounded shape for the nose and the mouth.

2 Add construction lines to show where the center of the head and the nose are. This will help place the eyes in the correct spot.

3 Add the eyes and nostrils as well as the mouth. Draw large horns on the top of the head.

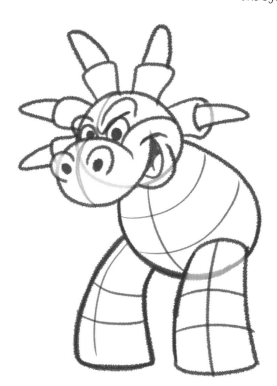

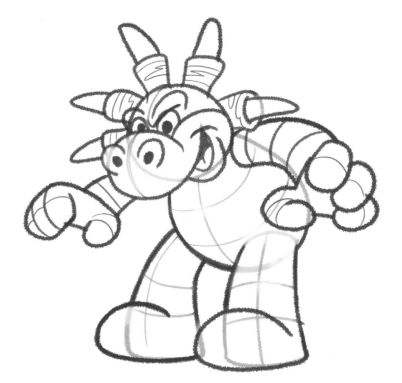

4 Draw the body and the legs. I added rounded lines to help me understand the three-dimensional form of the shape.

5 Add the feet, arms and fingers. Once again I used those construction lines to understand the rounded forms of the arms and fingers.

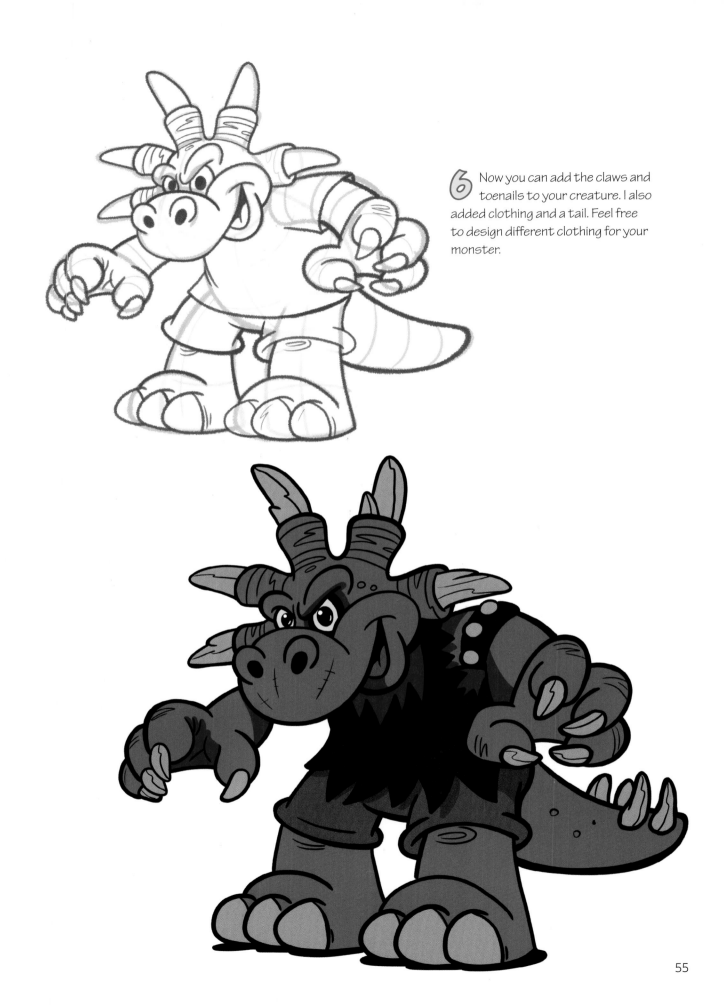

6 Now you can add the claws and toenails to your creature. I also added clothing and a tail. Feel free to design different clothing for your monster.

Punk Zombie

Zombies are all the rage right now and this putrid punk crawled out of his coffin to create havoc and mayhem. Learn how to draw this decaying dude in a few simple steps.

1 Start with the shape of the head and the construction lines to know the placement of the eyes and mouth.

2 Zombies can have so many different looks and features to them. Maybe your zombie is missing an eyeball?

3 Work on the expression and on shaping the cheekbones of this dead creep. The zombie's face will look a lot like a skull.

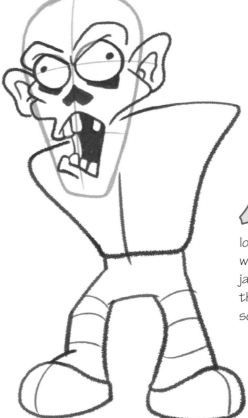

4 I wanted to make my zombie look like a punk rocker with a large leather jacket on. That's why the shoulders are so large.

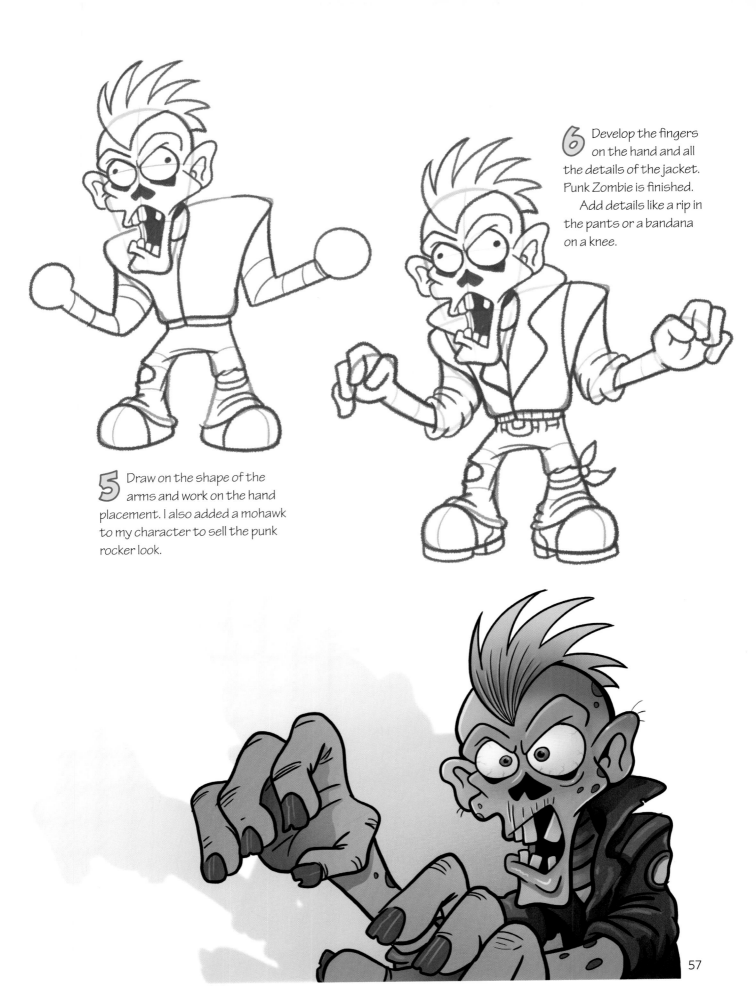

6 Develop the fingers on the hand and all the details of the jacket. Punk Zombie is finished. Add details like a rip in the pants or a bandana on a knee.

5 Draw on the shape of the arms and work on the hand placement. I also added a mohawk to my character to sell the punk rocker look.

Minotaur Guardian

This mythical beast guards various treasures and paths to keep the hero from winning. In this drawing example, my original doodle or thumbnail isn't that different from the final character. Sometimes you just get lucky and land on a good character design right away. Trust your gut about what will work for your final character.

1 As in previous drawing examples, start with a very rough doodle or idea for your character. Then break that character down into its simple shapes or form.

2 Just looking at the creature's head you can see the simple shapes used to create it.

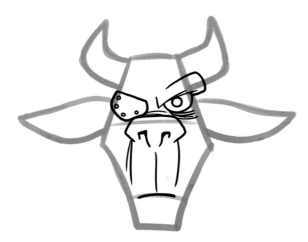

3 Begin with the placement of the facial features. Notice that I decided to leave out the nose piercing from the rough doodle in step 1.

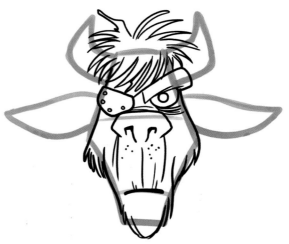

4 The hair is added to the character along with the furry outline of the face.

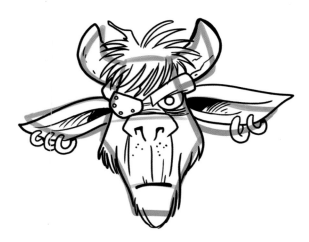

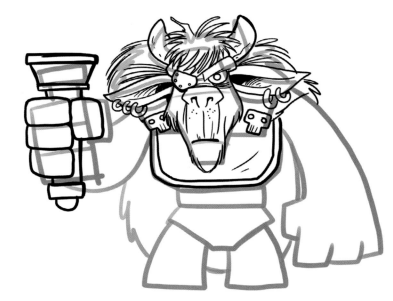

5 Always feel free to change your drawing from the rough idea. I decided to add many earrings to the Minotaur.

6 Now that the head is finished it's on to the creature's body. Design the armor and the fur cloak. Then block in the simple shapes for the hand holding the torch.

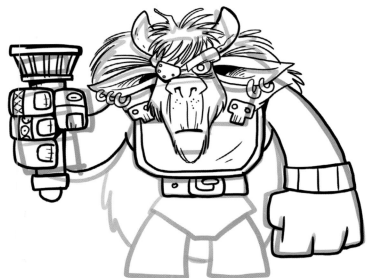

7 Now draw the details on the torch and on the hand by adding various rings and fingernails. You can get as detailed as you like with your character.

Here is the completed character. His stance and build are very imposing and his look is stern. I added some dark shadows to the fur cloak to make the body pop a bit more.

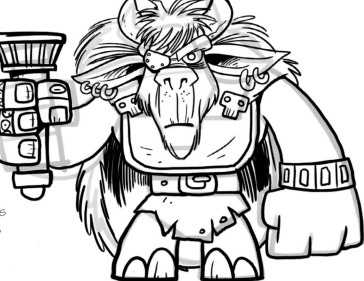

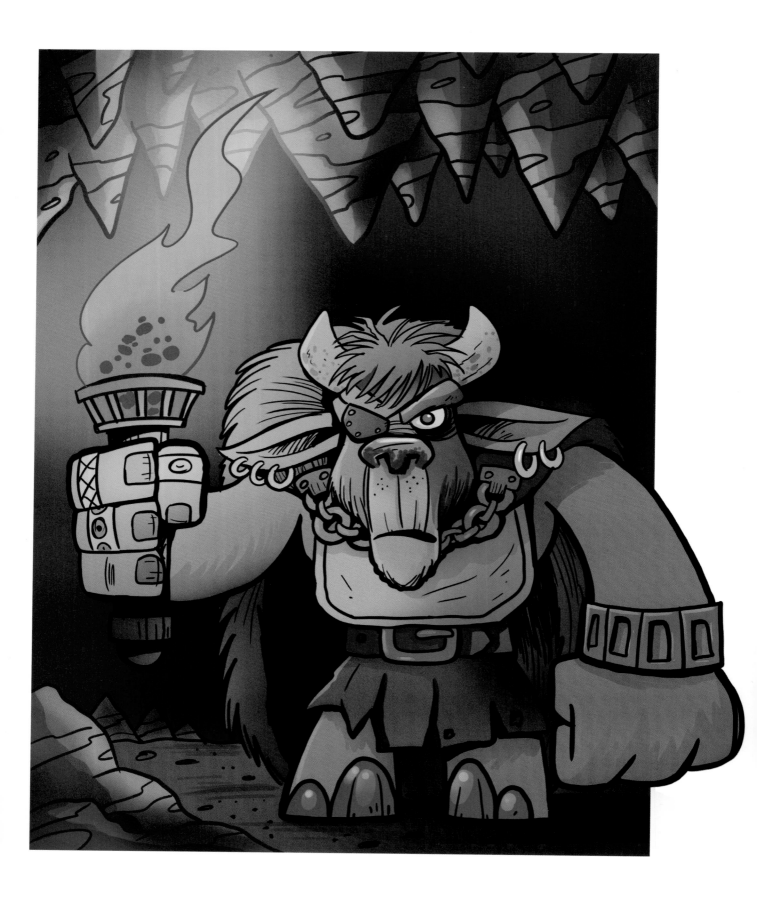

Unique Poses

Drawing your character once is a good start, but you will need different poses to make the character right for a video game. Good thing the process for doing this is still the same as drawing the character the first time! Simply sketch a rough idea for the pose. Keep in mind the shapes and the form of the character. Everytime you draw your character in a new pose you are learning more about your character and its personality.

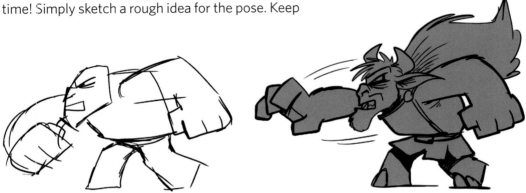

Your thumbnail sketch is merely an idea. Feel free to break away from the rough idea and try other poses. Here I had a closed fist for the rough idea but decided on a grabbing hand for the final.

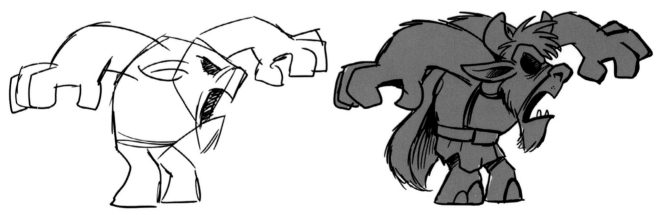

Not only do you want to draw the body in an interesting pose, but think about the position of the fingers and the shape of the mouth. These can lend a lot to the character's overall pose and sense of action.

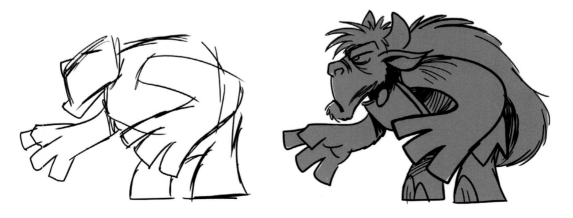

3 BLOCK WORLD

French Fries?

It might sound strange to think of french fries when drawing, but if you look at a lot of video game characters, it looks as if they had body parts made out of french fries. Try drawing a french fry video game character now!

Twist and bend your french fry drawings to see how they can become body parts for your video game character. Who says you can't play with your food.

Block Hero

Here are the basic forms of the character and a few suggestions for enhancing a block character drawing.

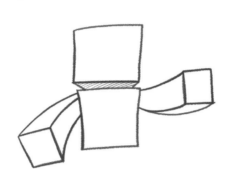

1 Start with a square shape for the head and a rectangle shape for the body. Notice the rectangle body tapers in on the sides making it look more like a human torso.

2 Add dimension to the head to make it a cube and attach french fry arms. Notice the arms have a slight bend to them.

3 Draw cubes for the torch in the hand and then two french fry legs.

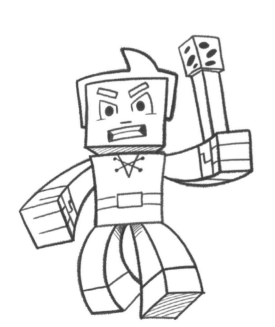

Hands
Here are some hands at different angles. Notice where the lines for the thumbs and the fingers are.

4 Here is where the details are added to the character. I even added an extra shape for hair to make the character a bit more interesting.

Dynamic Hero Poses

Here is a great exercise in drawing poses using those bendable french fry shapes. Try creating a page full of poses for a block character. Don't add any facial expressions; just try using the poses to tell your character's mood or action. It might be challenging at first, but it becomes strangely addictive after a few poses.

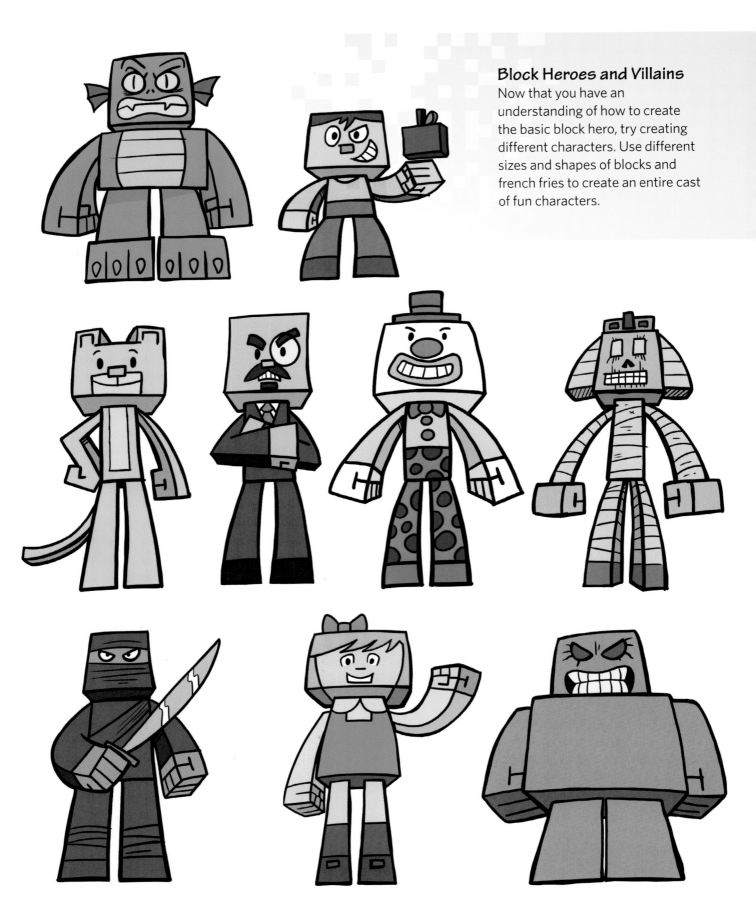

Block Heroes and Villains
Now that you have an understanding of how to create the basic block hero, try creating different characters. Use different sizes and shapes of blocks and french fries to create an entire cast of fun characters.

Block Beasts

Maybe your hero walks on four legs or flies like a chicken. You can easily construct various animals by arranging blocks to all kinds of animals big or small.

Bear Drawing

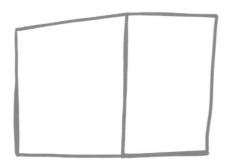

1 Start with a large cube shape for the bear's massive body.

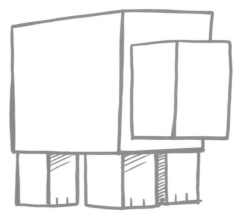

2 Add three rectangles for the legs and paws and another cube for the bear's head.

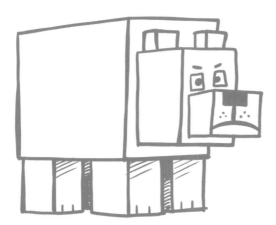

3 Now create a cube for the muzzle and snout. Add the facial features and ears. The fourth leg is barely visible, so just add a shadow to note that it exists.

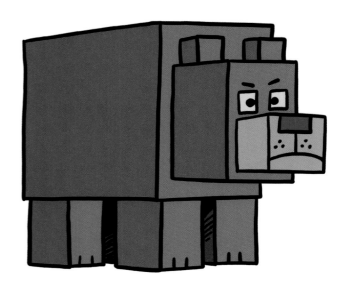

Chicken Drawing

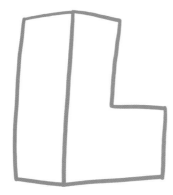

1 Draw a block that looks like the letter L.

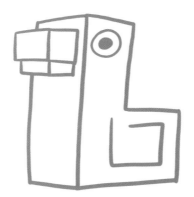

2 Add a wing and an eye. Then draw the beak of the rooster using two blocks.

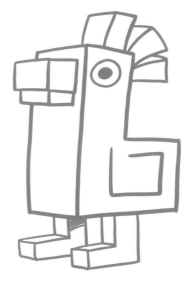

3 Now add the comb on the top of the rooster's head. Also add backward L-shaped blocks for the feet.

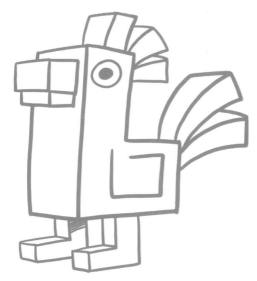

4 Draw some of those french fry shapes for the rooster's tail.

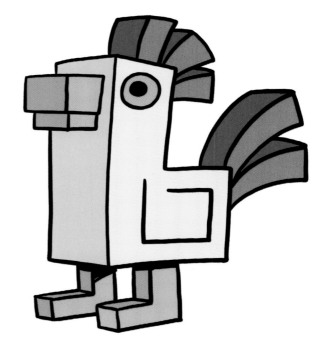

Cat Drawings

The same basic block drawing can be used for a variety of different cats. Just give them different details for fur or accessories!

1 Start with a square and a rectangle joined together.

2 Add longer rectangles for legs. To make sure the feet line up, correctly add guidelines at the bottom.

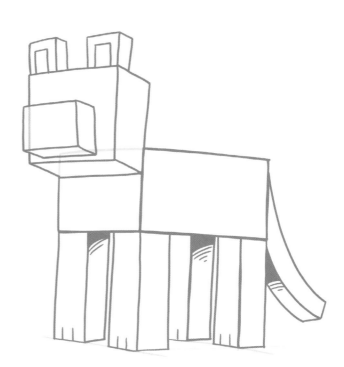

3 Draw a box for the head and face. Add shadows to the underside of the legs. Also finish the feet and erase the guidelines.

4 Now add a tail and ears. Also draw another box for the muzzle of the feline.

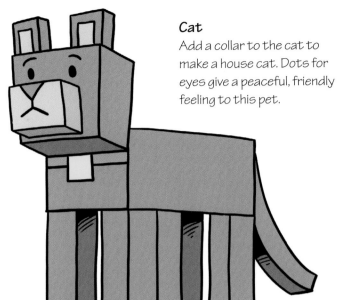

Cat

Add a collar to the cat to make a house cat. Dots for eyes give a peaceful, friendly feeling to this pet.

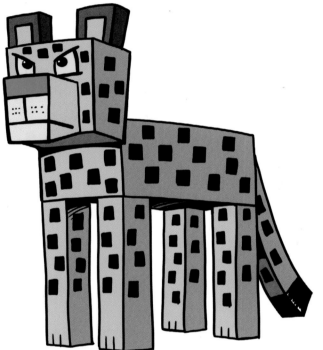

Cheetah

For a cheetah you will need bigger ears and longer, skinnier legs than the cat. A cheetah will have a longer tail than a house cat, too.

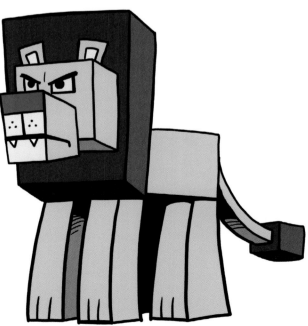

Lion

Add another cube for the mane and a cube for the end of the tail. Make the bottom of the legs thicker to show weight and strength.

Block Dragon

To create a more complex block character you will need to rough out the organic form of the character. Don't get detailed in this step. Keep it very basic and loose.

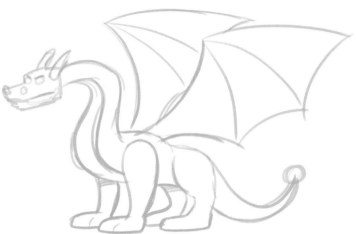

1 Draw a simple dragon form so you have an idea of how to start creating the boxes in the next step.

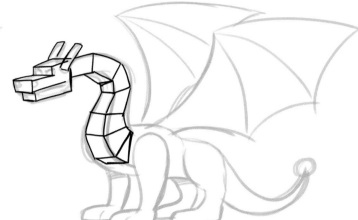

2 Trace over the rough form or just use a pen and begin creating all those box shapes. This might take a few tries, so I suggest using tracing paper so you don't have to start all over again if you make a mistake.

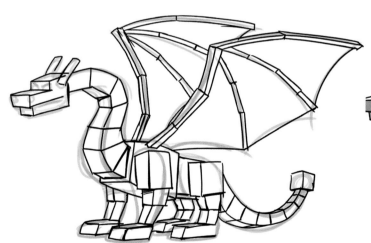

3 Keep adding boxes and rectangles until you have a rough form for your dragon's body. Remember not to get detailed just yet.

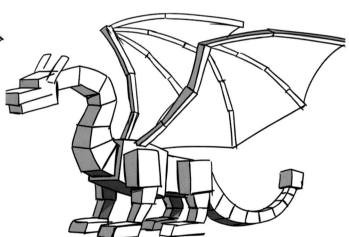

4 I added some shading to the boxes so I could easily differentiate the front surfaces of the boxes from the side surfaces.

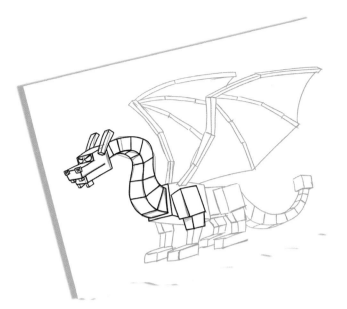

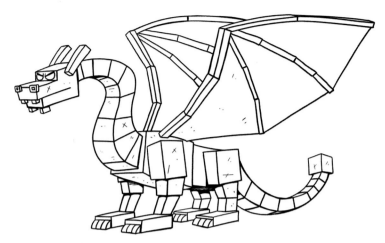

5 Time to redraw this character. Use tracing paper or regular sketch paper to create your final dragon. Take your time on the final drawing.

6 I added some scratches and dings to my boxes to make the surfaces of the boxes look more interesting and to add some details for the eyes to pore over.

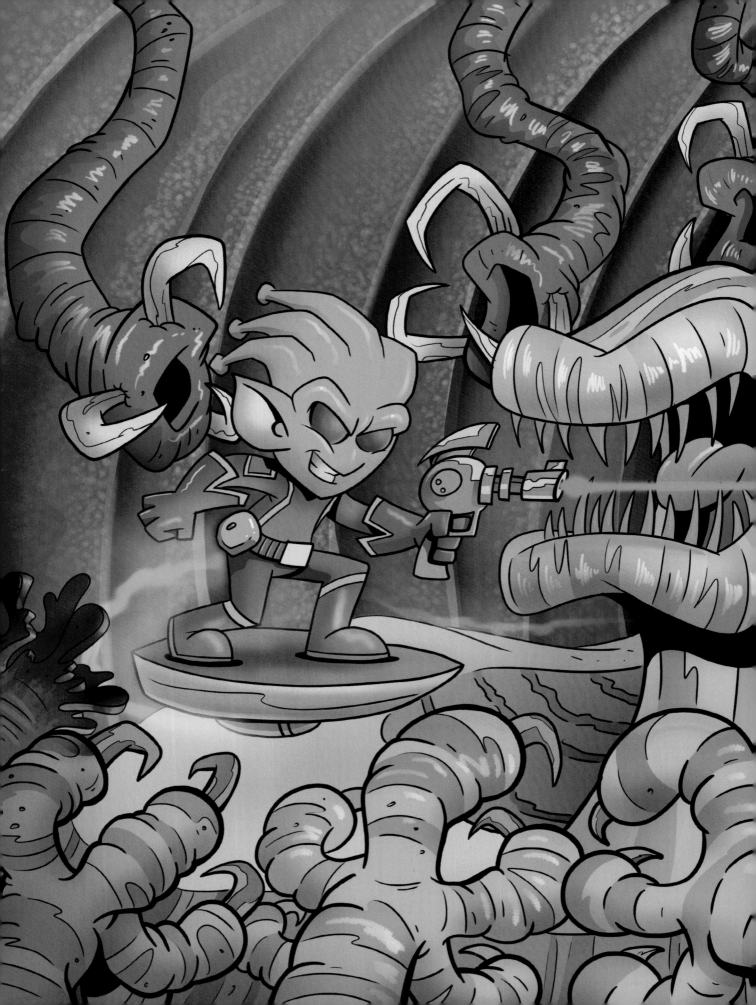

4 WORLDS AND LEVELS

Upgrade Your Art Supplies

Art Programs

I work in a program called Adobe Photohop. This program allows me to draw and make an unlimited number of corrections to the drawing. I can easily change colors, resize my drawings, flip my art any direction and allow for multiple changes. Adobe Photoshop is a premium tool for a wide variety of art professions. But there are other programs that can do the same thing for much less money and still produce amazing results. Examples of these programs are SketchBook Pro, ArtRage and Procreate. The key thing you want in a drawing or art program is a feature known as layers.

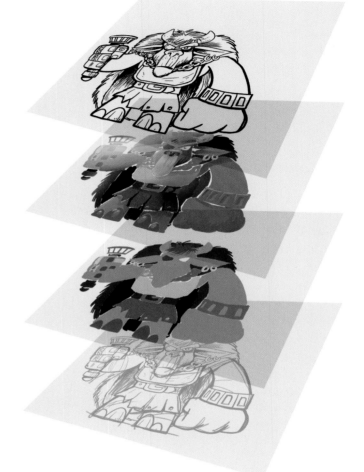

How Layers Work

What are layers? Imagine sheets of transparent paper on top of one another that you can draw and color on. Each sheet of transparent paper can be moved or thrown away. Layers allow a greater freedom to your drawings. My rough drawing is the bottom layer. Next I created a layer for my inked drawing (black line art). Then I inserted two more layers for coloring. One layer is simply the flat color or my base color. The other color layer is where I did my highlights and shadows.

Computer Equipment

I work on a Wacom Cintiq monitor that is hooked up to my computer. I can draw on this monitor just like I would a sketchbook. It is a hefty investment, but I would highly recommend it to any artist who wants to become a professional illustrator. For those artists just starting or wanting to create amazing computer work for a much smaller price, there are many great tablets available that allow you to draw on them.

Drawing Tablets

A great way to start working digitally without spending a ton of money is to purchase a tablet. Apple, Samsung and Windows all make tablets you can draw on (for example, the iPad). Tablet technology is changing so quickly that any tablet I list or recommend will be obsolete shortly after the printing of this book. What you want to look for in a tablet is that it comes with a pen device and has pressure sensitivity. Pressure sensitivity allows the tablet to know how hard or soft the pen device is pressing on the screen. This allows for thin or thick lines depending on the kind of pressure applied. Make sure to try these tablets at a store before buying to see what you like and don't like about drawing on these digital devices.

Okay, enough tech talk. Can we get back to drawing now?

Creating a Side-Scrolling Background

When creating a side-scrolling video game, you need to create your levels in layers. Here is an example of how I created a world using different layers.

Middle Ground

I started with the middle ground. The middle ground is the layer that the characters will interact with in each level.

Sky

The sky will also move on its own layer and help to create mood and motion for this living video game world.

Now all the elements come together to create the side-scrolling lava world. Notice the addition of the foreground layer at the bottom. Not every game has this, but it can help to create depth in the game and intensify the mood.

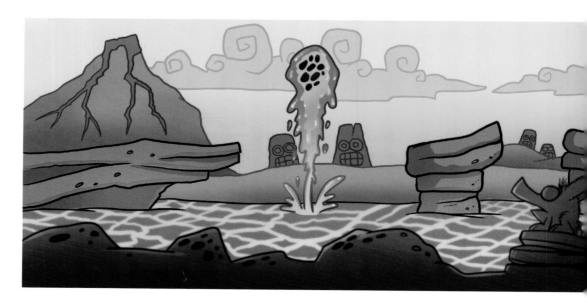

Background

The background layer will scroll or move independently of the middle ground layer. The background will also add a sense of depth to the world.

Characters

You will want to see how characters interact with the levels. New characters might have to be created with traits specific to that level.

Under the Sea

In this book we've hit almost all the worlds that are common to most video games: space world, lava level, jungle scene and now, a water world. First rough out your idea on a scrap piece of paper to get your general ideas for the shapes and forms of this ocean terrain.

Jellyfish

1 Draw an upside-down U shape with a wavy line at the bottom.

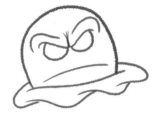

2 Add the angry eyes and a mouth. Also work on the bottom of the body.

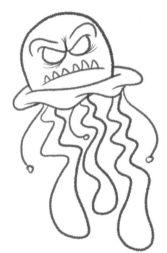

3 Decide what kind of teeth you want to add. I drew many teeth pointed up, but you can have them pointed down. Next add the tentacles.

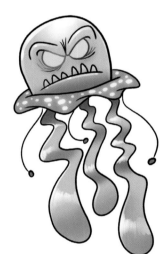

If this jellyfish stings your hero, it is game over.

Piranha

1 Draw a shape like a lemon.

2 Next add the eye and bottom lip. Draw the lines for the fins.

3 Now draw in sharp teeth and gills. Add a second eye and finish the top fin and the bottom fin. We're almost finished! Add the lines for the tail and the fin on the other side of the body.

4 Complete the tail and the fin at the bottom and then erase the lines not needed.

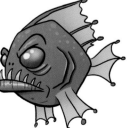

Using a rough sketch, we can now create the final background. I started with the middle ground first. Block in the rough shapes of the cave.

Next work on all the intricate details for the cave. I added barnacles and starfish and some ancient decorations to show this is not just any cave.

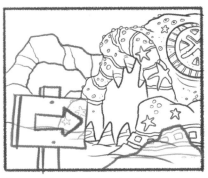

Now we can work on the foreground (green) and background (red). I broke the image up like this so I could plan the scene. Using layers will allow you to move items as needed later on.

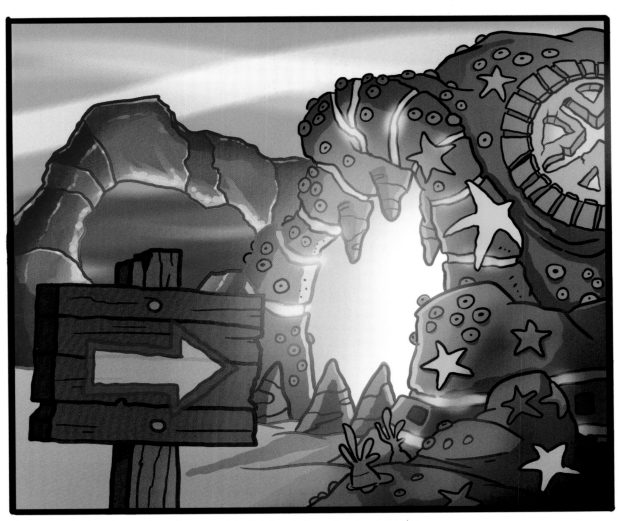

The sign tells the player where to go next in this level. By swimming into this underwater cave the player moves to the next level. You might use more clever ways than this to explain to the player where to go next, but sometimes, obvious things like a sign can save a player from frustration in your game.

Way back in chapter 1 we drew an alien named Zumona who wanted to save her planet from being eaten by a giant space slug. Her only way to defeat this giant world eater is by flying into the monster's mouth and destroying enough vital organs before it eats her planet. Here's an example of creating a level or world based in the disgusting innards of a humongous planet-eating space slug.

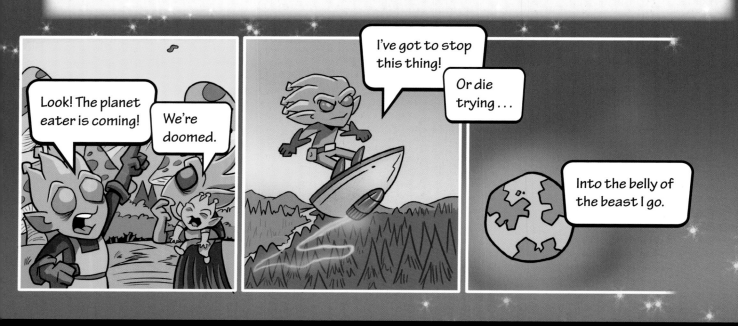

Look! The planet eater is coming!

We're doomed.

I've got to stop this thing!

Or die trying . . .

Into the belly of the beast I go.

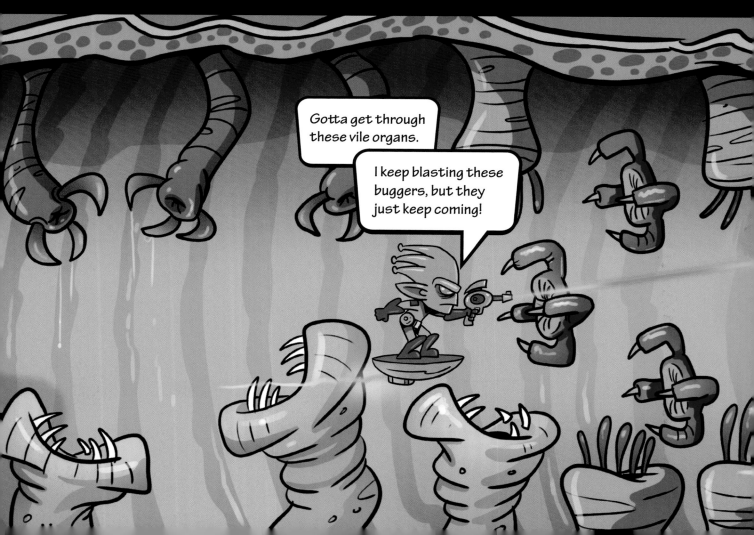

Gotta get through these vile organs.

I keep blasting these buggers, but they just keep coming!

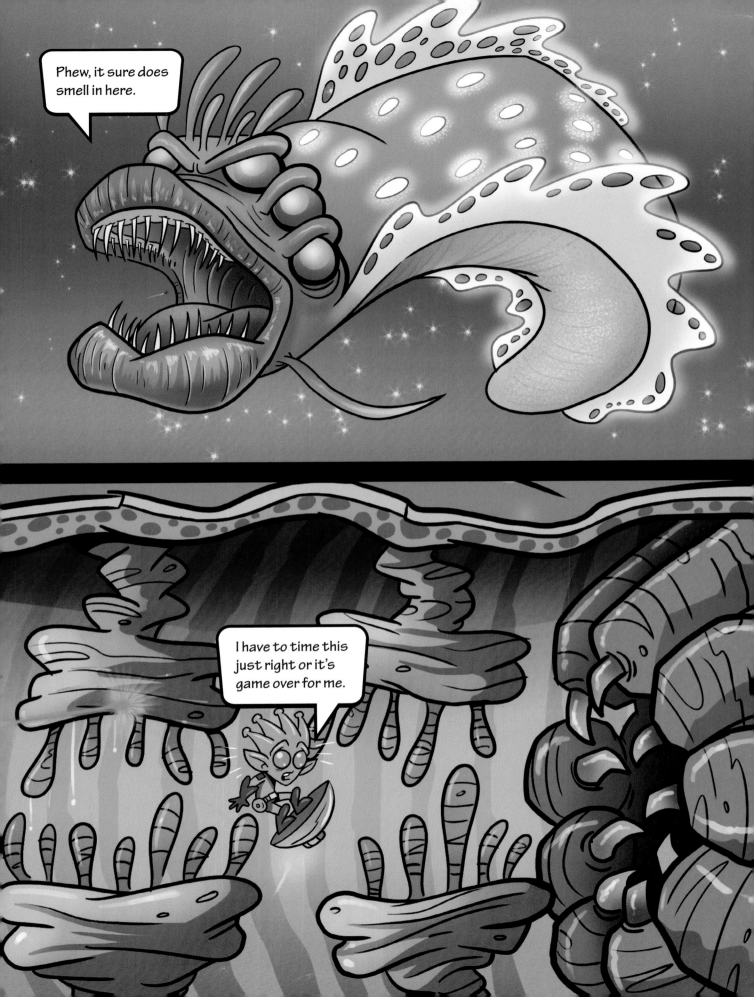

Innard Monsters

Learn how to draw the innard monsters that Zumona has to defeat.

Talon Worm

 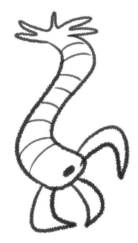 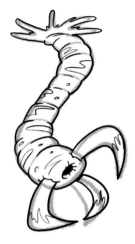 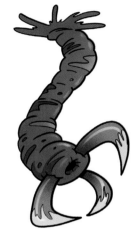

1 Draw a simple line.

2 Draw lines on the body to define the tubular shape. Sharp talons and suction feet are added to the ends of the body.

3 Ink the character and define more details to create a more interesting shape and design for the body.

4 Now you have a disgusting worm that can eat a small car.

Slug Chomper

 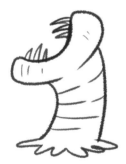 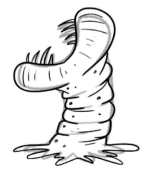 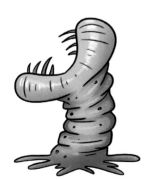

1 Start creating the form of the chomper.

2 Add the teeth and some lines to define the tubelike shape of the body.

3 When inking the chomper, don't trace the lines but use them as a guide.

4 Add color to your monster. This bad biter is ready for his dinner now.

Blood Sucker

1 Draw a shape that looks like a vitamin or a candy.

2 Now add a dark circle in the center and then two shapes protruding from the top and bottom.

3 Now draw the same protrusions on the sides. Draw talons at the end of each protrusion.

4 When you add ink, draw small lines to create a texture on the creature.

Check out this nasty little creature . . . actually it's pretty big.

Fang Worm

 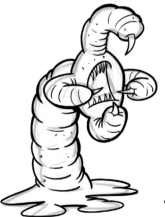 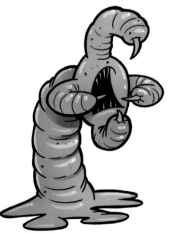

1 Start drawing this character in a loose and rough sketch.

2 This creature is a combination of the Slug Chomper and the Blood Sucker, so add the protrusions the same way as with the Blood Sucker.

3 The fun part is going over the drawing again and adding all those fun details to the skin and the nasty teeth.

4 A good way to make your creature look slimy while you're coloring it is to add white highlights to the skin.

3-D Worlds

There are also games where the characters play in a three-dimensional environment. I am going to give a very basic example of how the design for a 3-D world works. I don't want to go too far with this because there are a significant number of books dedicated to drawing only landscapes. This is just a simple example of how I created a three-dimensional world for characters to interact with.

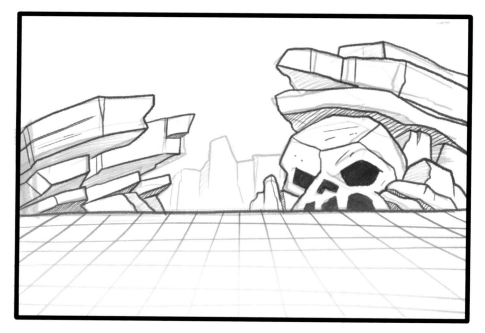

1 Start with a background. The rock formation that looks like a skull is the focal point of the game. We want the player to get the hero to the skull cave. Draw a simple grid so you can see the perspective of this world. This will help mainly for the middle ground on the next step.

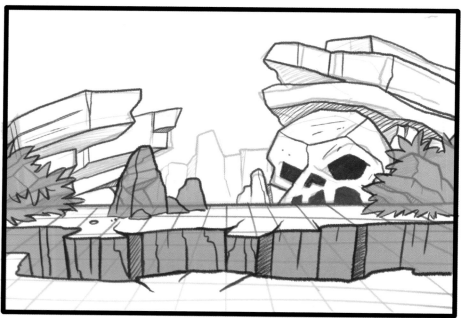

2 Now the middle ground leaves our hero with a bit of a challenge. She has to cross the large ravine to get to the other side and then progress on to the skull cave. The grid lines help me decide on the placement of the ravine.

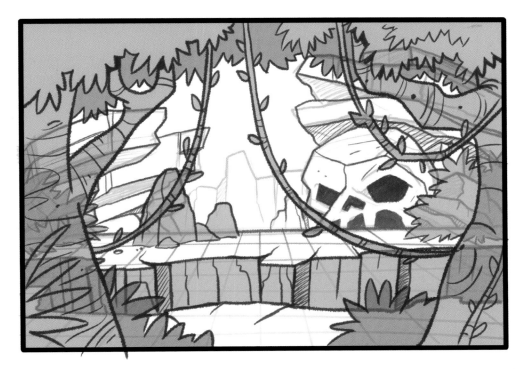

3 The last thing to create is the foreground layer. Use the trees and vines to create a frame around the background and middle ground images. Putting each level on its own layer allows for easy adjustments.

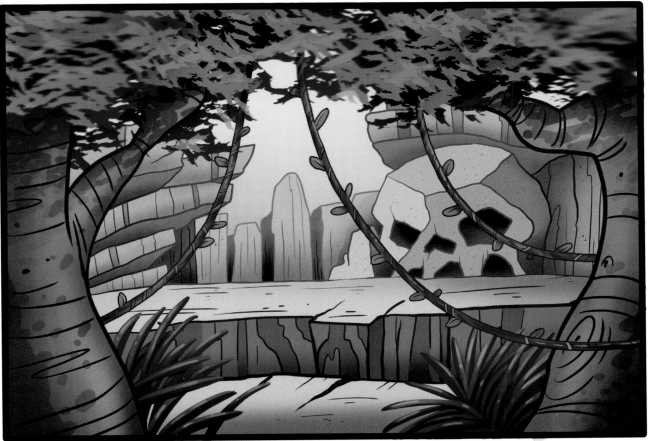

4 Even when you go to the final art level, leave elements on different layers so you can remove or add these elements as needed. Here I removed a set of rocks and some bushes from the middle ground so the scene looks less complicated.

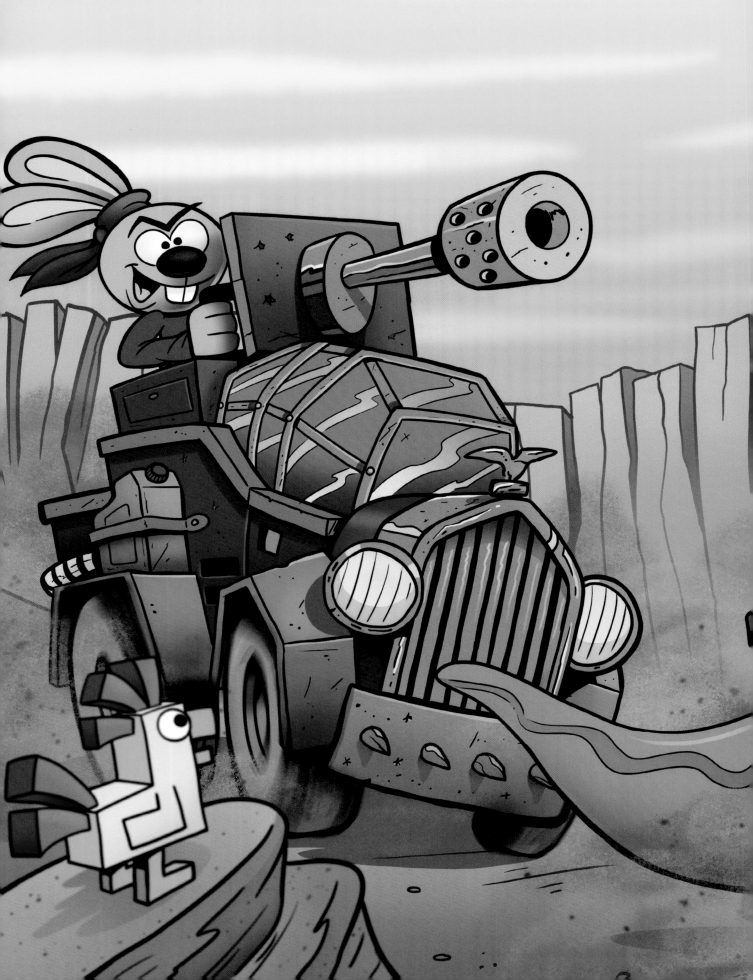

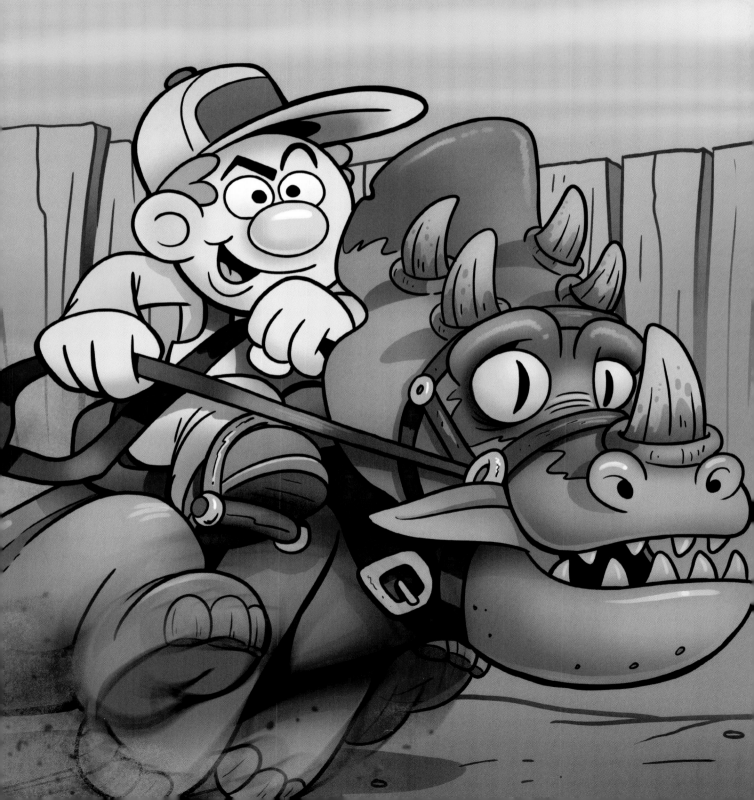

5 VEHICLES, SPACESHIPS AND SWEET RIDES!

Cars and Trucks

On these pages we'll take simple shapes and create fun vehicles for the characters to move around in. What shapes can you use to create strange or complex cars?

Spike Mobile

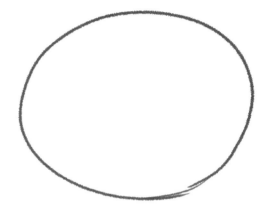

1 This car starts with a simple egg shape.

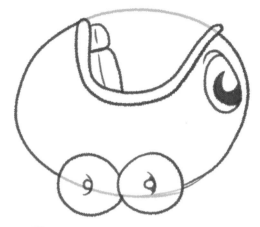

2 Draw the doughnut-like wheels and an eye for a headlight. Carve a slice out of the egg shape for the driver's seat.

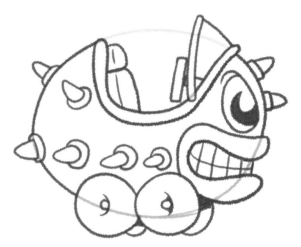

3 Add a windshield and a smiley face grill with big lips for a bumper. Then decorate the body with some sharp spikes.

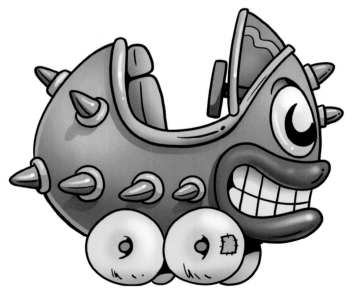

Beetle Car

1 This fun little vehicle starts with a bean shape.

2 Add a line for the start of the windshield. Create the curved shapes for the wheel wells for the three tires.

3 Draw the three tires and the headlight. Start placing the area for the driver's seat.

4 Finish the windshield and add the steering wheel. Now decorate the car to look like a happy little bugmobile.

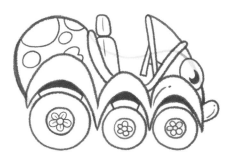

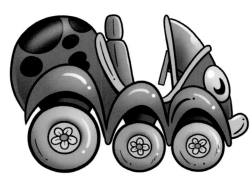

Trank (Part Truck, Part Tank)

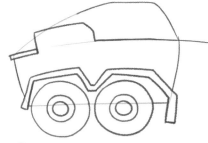

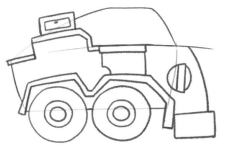

1 This truck/tank starts with a boxy structure and a sloping top.

2 Add the wheels and the armor runner that protects the wheels.

3 Start building the front of the car complete with headlights and a large metal bumper.

4 Draw a turret and add a metal frame to the windshield. Add more details to this monster mobile to make it epic.

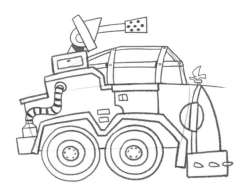

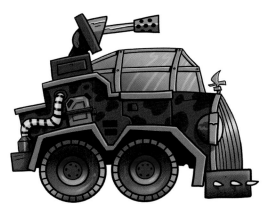

Flying Machines

I try to think of flying creatures when I design spaceships. Here are three different styles to try.

EX-99 Stealth Fighter

1 This first spaceship has the look of a fly. Start with some sleek shapes.

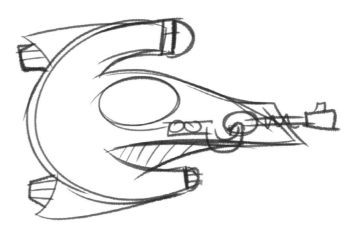

2 Build upon those shapes keeping everything loose and general. I looked at shape and form the entire time.

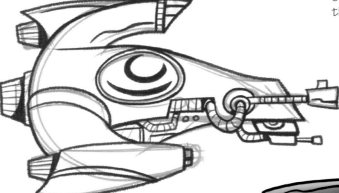

3 Now go over that loose sketch and start adding the solid lines to really define the shape of this sleek fighter craft.

This fighter has some sweet-looking guns and is ready to take on any ship in the universe.

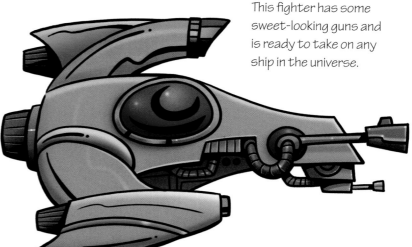

Spirit Transport Ship

1 In this example I thought more of a bumblebee shape. This ship is a passenger ship and not used for fighting.

2 I wanted this ship to be big and bulky. Add a large engine to the side of the ship and a huge windshield.

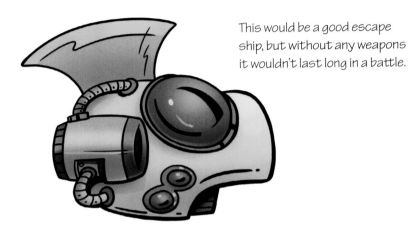

This would be a good escape ship, but without any weapons it wouldn't last long in a battle.

3 Go over your rough sketch and start committing to the final drawing by adding solid lines for your final ship.

T-88 Raptor

1 For this final ship I thought of an eagle or hawk shape. Rough out a form that is sleek and sharp, just like a bird of prey.

2 I decided it needed to also be sleek towards the back of the ship, too. Add a small gun on the side and an extra engine part on top.

3 Details and more details! This ship has some exposed engine parts and fuel tubes. This adds some extra visual interest for the eye to look at.

A sleek, mean fighting machine, ready for its first mission.

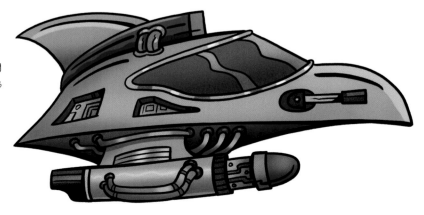

Animal Transport

On some strange planets the best way to travel is by monster or beast.

Beast of Burden

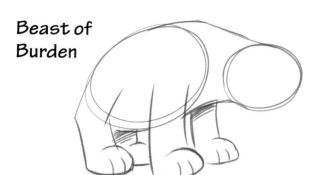

1 Start planning the form of the creature's body.

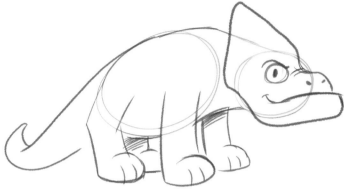

2 Elaborate on the form a bit more and add the tail and head of the creature.

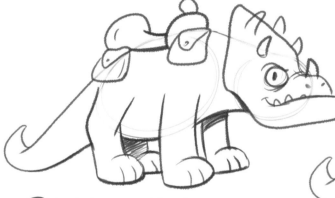

3 Look at some saddle references online so you have an idea of the shape, but be sure to add some of your own touches to it.

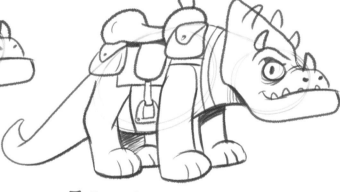

4 Keep refining the shapes and add some fun details. Straps are important to show this saddle is firmly connected to the creature.

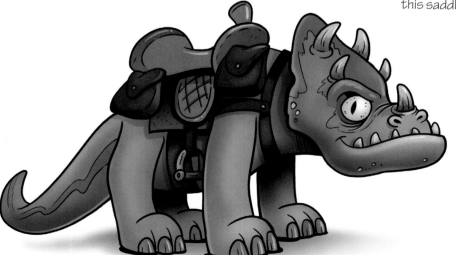

This is a monstrous beast that makes traveling through tough terrain easy. Just make sure to feed this creature when it gets hungry, or it might decide to snack on you.

Crab Submarine

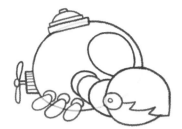

1 When I created the spaceships I thought of birds, so it makes sense that when I drew submarines I refered to an underwater creature like a crab.

2 Start adding the details to the crab sub claw and a hatch on the top for exit and entry. Keep everything round when designing subs.

3 Draw the rounded window and the legs for walking in the bottom of the ocean.

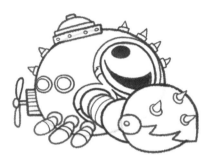

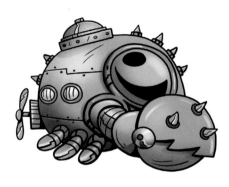

4 Add a nice strong shadow in the window with some added chrome trim. The sharp spikes give a crustacean feel to it.

Fish Submarine

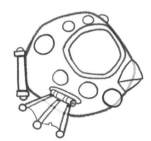

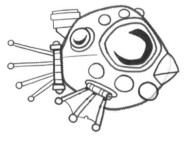

1 Draw a round form for the fish submarine, repeating the large fish eye window. This sub will use fins to move through the water.

2 Add a beak-like mouth and many rounded shapes for lights. This ship is for exploring the deep, dark ocean.

3 Draw a second window for observing ocean life and a hatch to enter the fish sub. Start the tail fin to make our fish sub swim through the water.

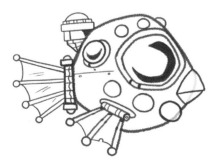

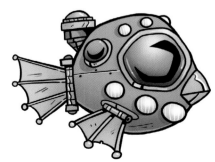

4 Get detailed! I added some bolts to show this sub is made of metal. I also added some dark shadows and scratches to reinforce the feeling of a metal surface.

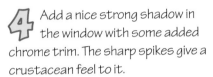

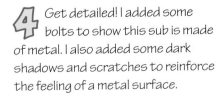

Army Ant Tank

Using animals and insects are great ways to come up with designs for vehicles. Insects like ants look like they have armor plating and pinchers for battle. What other kinds of animals look like they could be turned into tanks or battle ready vehicles?

1 To create this robot tank I looked to the ant, but if you want to draw only two legs, try using a turtle as reference. Start with two round shapes.

2 Next add the tank turret to the top of the back and use those french fry shapes for the legs. A large round shape for the window also will look like the ant's eye.

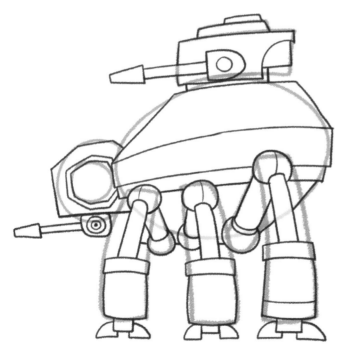

3 Once you have your basic shape, you can carve out and create the shapes of the robot. Now that you have the bones of your robot tank, you can start going crazy with details.

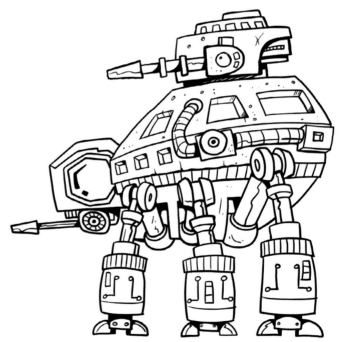

4 Go crazy with details and see what you come up with. Don't be afraid to draw it several times to see what details work and which ones don't.

Did I mention you can go crazy adding the details to your tank? Check out all these weapons and extras on this version. Can you count all the guns and cannons on this bad boy? Feel free to design your tank for various purposes: battle, transport, exploring new planets. You can use this basic design to create a wide variety of insect-like tanks and machines.

These tanks and vehicles might come in handy for the next chapter when we take on some big bad bosses. That's right, folks, we're getting to the end of the book and just like a video game, our book draws to an end with an epic boss battle.

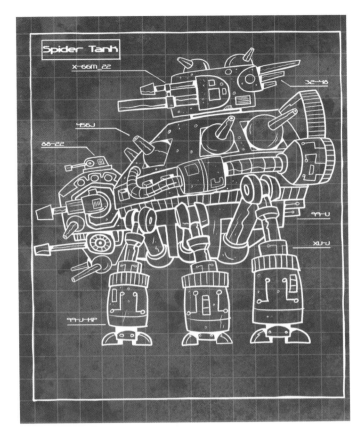

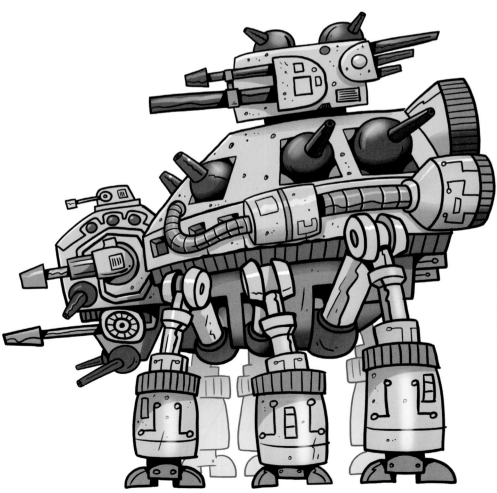

Notice that I didn't draw a detailed version of all six legs. I drew a hint of the legs on the other side of the tank's chassis.

6 THE BIG BOSS BATTLE

The Boss Level

A very important, if not the most important, part of your video game is the boss level. This level is not only a huge visual payoff for the game, but also the ultimate test of the hero's strength, courage and smarts. When designing your boss character you want to design not only the character, but also the world or environment that they live in. The big bad boss battle should have an epic feel and be a challenge to play and a wonder to look at.

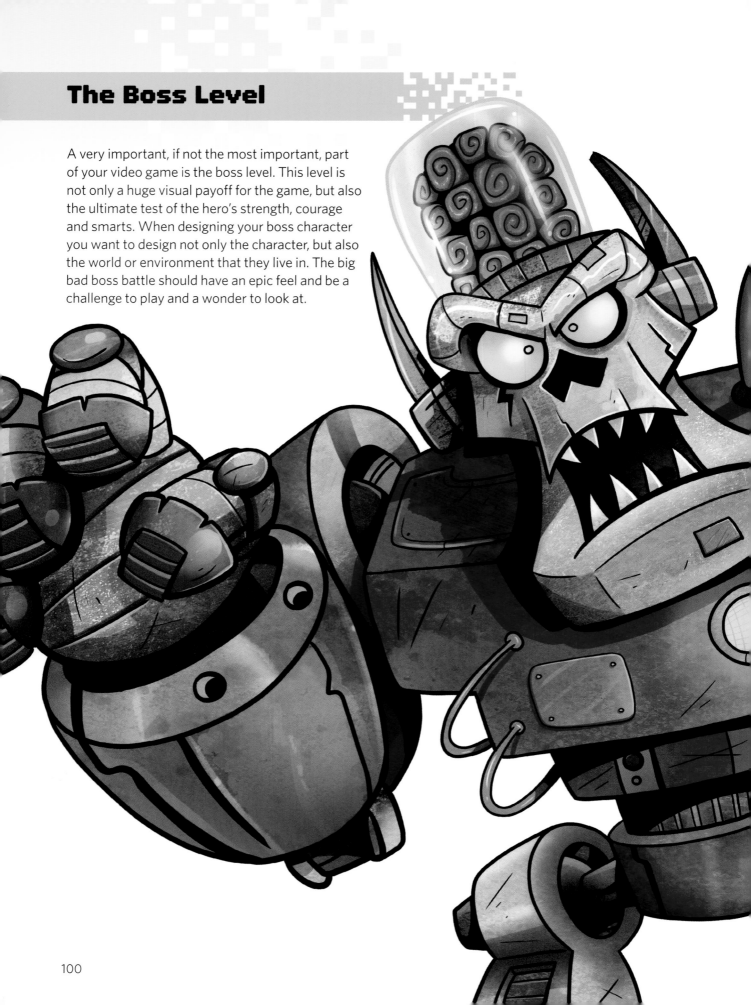

Big Bad Boss—Mr. Whiskers

Before we start designing mega monsters and creepy creatures, I wanted to show that a boss-level character can also be small and quirky. Mr. Whiskers is a tough cat that rules the alleyways and sewers of the city's seedy underworld.

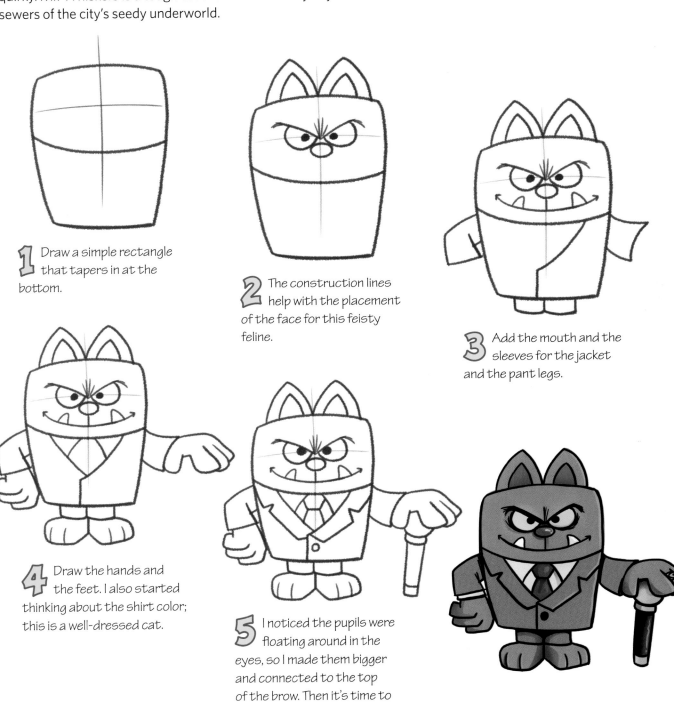

1 Draw a simple rectangle that tapers in at the bottom.

2 The construction lines help with the placement of the face for this feisty feline.

3 Add the mouth and the sleeves for the jacket and the pant legs.

4 Draw the hands and the feet. I also started thinking about the shirt color; this is a well-dressed cat.

5 I noticed the pupils were floating around in the eyes, so I made them bigger and connected to the top of the brow. Then it's time to finish this drawing by adding a tie and a cane.

Whisker Bot 3000

The evil Mr. Whiskers doesn't play fair. No, he operates a giant robot to take on his nemesis. Luckily for our hero, this robot has a weak spot. Find that weak spot and after a few repeated hits, this robot will become a bucket of bolts.

I wanted a cross between a cat-looking robot and a tall two-legged robot, so I combined two rough ideas.

1 Draw a curved line with a rectangle on top of it. Also add construction lines to help place the robot's face.

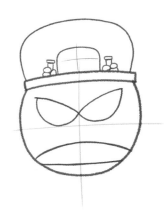

2 Start adding the robot's eyes and mouth. Then work on adding the hands and body of Mr. Whiskers.

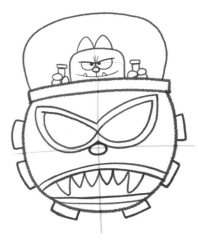

3 Add more details to both the robot's face and Mr. Whiskers. Next draw rectangular shapes to show where the arms and legs will go.

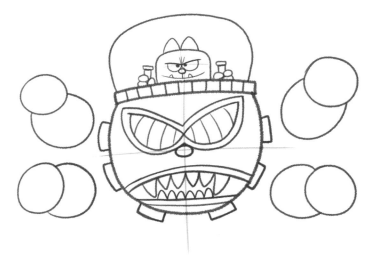

4 Now add circle shapes for the hands and then elongated ovals for arms. Add the shapes for the feet and more details to the robot's face.

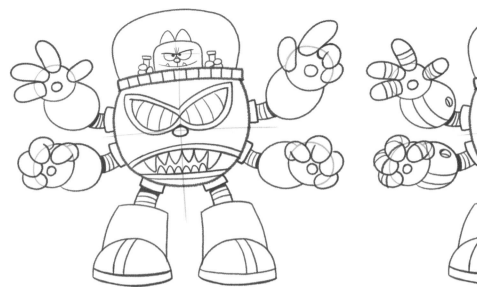

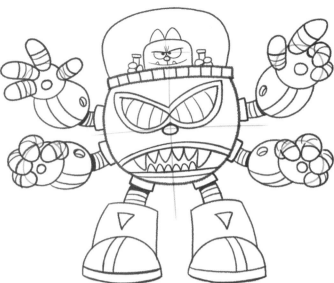

5 Time to connect the arms and legs to the robot's body. Add the fingers to the hands. I will often break up large shapes by adding a design element like the lines or stripe that I added to the feet of the robot.

6 Draw some more details like the stripes on the arms and the holes for the bolts that allow the arms to pivot. Add as many decals or details as you like and remember that you can keep adding to this character in the inking stage, too.

If you're having trouble making this character look the same on both sides, remember to use the trick from page 34.

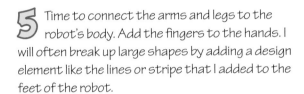

When I inked these characters I decided to make the robot look like it's been in several battles and some bad fights.

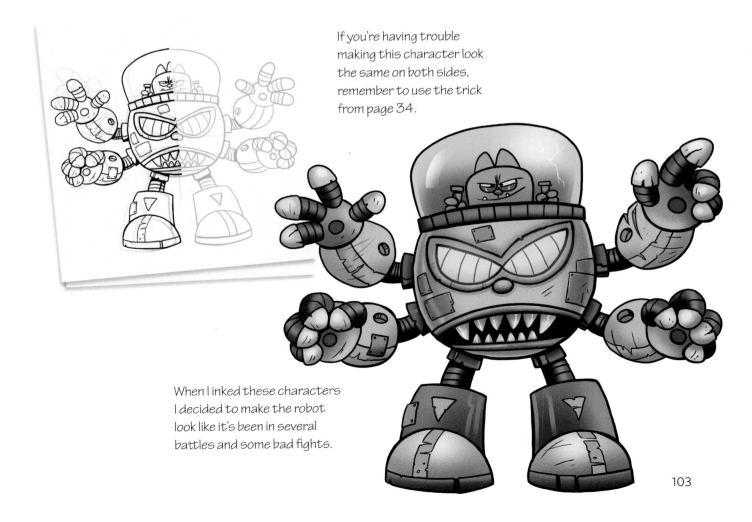

103

Brain Beast

Brains are amazing looking and gross at the same time. A giant monster brain would be an awesome creature to have to fight in an epic boss battle. I first drew up this rough thumbnail of the scene for the brain beast and its evil lair.

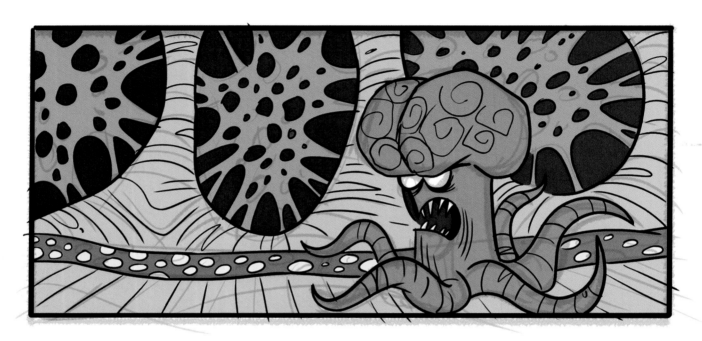

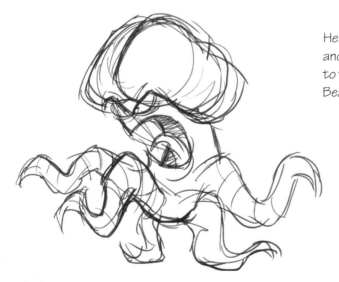

1 This creature is not that hard to draw. Scribble the rough form knowing that as you draw it you can make changes at any time.

Here I added another tentacle to the Brain Beast.

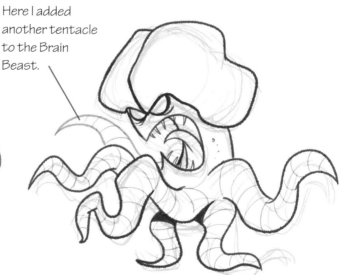

2 Outline the form of the creature. Draw curved lines around the tentacles so you can understand the rounded shape of them when you add details in the next step.

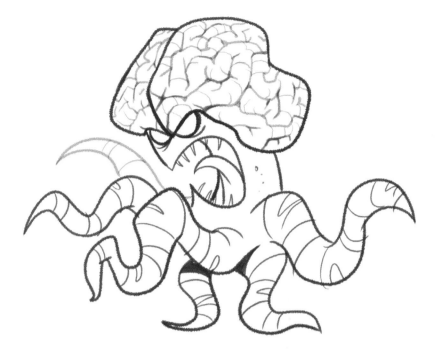

3 Okay, time to clean up the drawing and add those wonderful details! I used a picture of a brain from Google images to draw the intricate folds and curves of the brain. Reference images are always a must when drawing something from life.

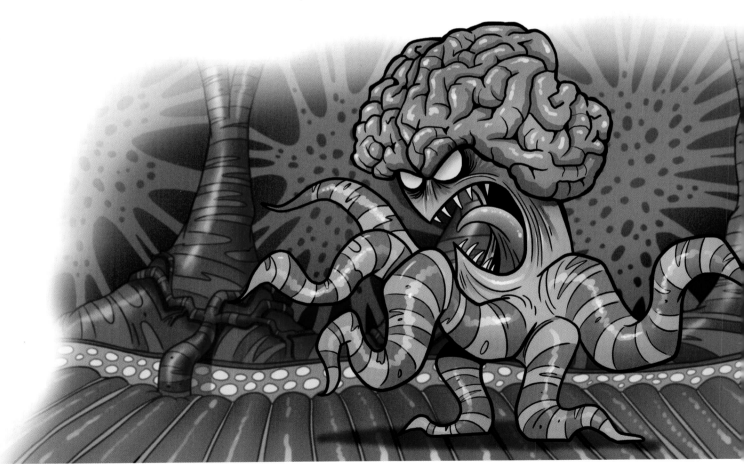

You can see the thumbnail idea and the finished drawing have many differences and also many similarities. Play around with your ideas and have fun with them. Let the ideas flow onto your paper.

Big Boulder Boss

The hero sees a light at the end of a long cave and walks towards it. The light leads to a large crater full of boulders and large rocks. Our hero steps into the light and the exit of the cave slams shut . . . it's an obvious trap! The ground rumbles and shakes and the boulders move and shifts slowly creating the form of a giant rock monster. How will our hero beat a mega-huge monster made of rocks?

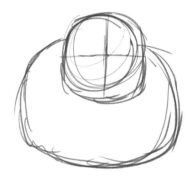

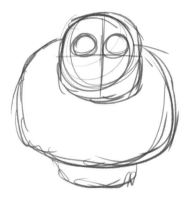

1 Start with two boulder shapes, one for the head and a larger one below for the chest and torso. Add lines to the head for the placement of the face.

2 Now add the rounded eyes for the rock monster and then a flat rock shape for the waist.

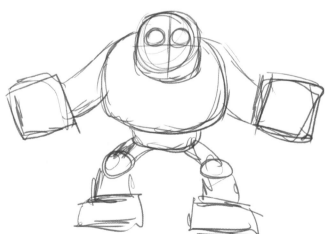

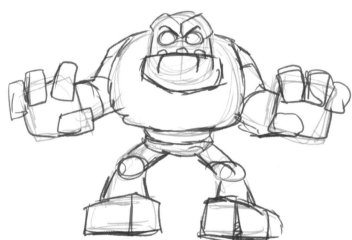

3 Next add the arms and then two large squares for hands. We want the hands to be enormously exaggerated. Draw circular boulders for kneecaps and rectangular rocks for the feet.

4 Add the shapes for the fingers. Now is also the time to add more features to the face of this boulder bad guy.

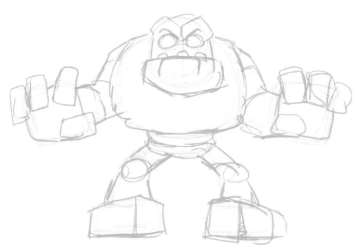

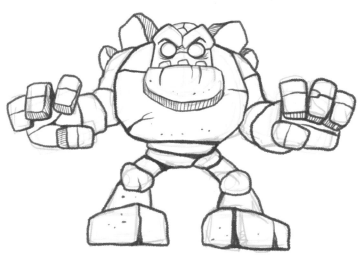

5 Erase the rough drawing of the monster so there is a very light trace of the creature's forms, or lower the opacity on the layer if using a drawing app on a computer.

6 Now start adding details and the outline of the final rock beast. Make sure to add some texture to the character's body to convey the look of rocks and boulders.

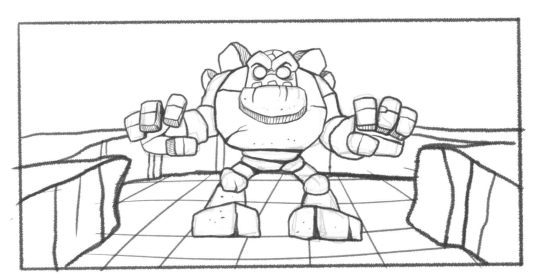

Create a background for your big boss beast. Draw the cliffs smaller than the giant monster to show how big this creature is. Maybe add a tree or a building to the image to give the viewer an idea of the giant's enormous size.

You might get stuck trying to come up with an idea for a character. Here's a trick to help your eyes and mind see all kinds of shapes and forms for new characters.

Or maybe you've looked at some clouds and seen a dragon?

Have you ever been in a dark room and you think you see something strange?

Only to quickly turn on the light and realize your eyes were playing tricks on you?

Well, you can use your same overactive imagination to turn paint blobs into really amazing characters.

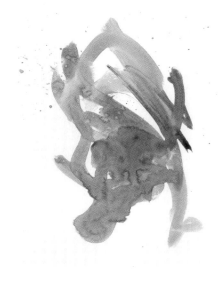

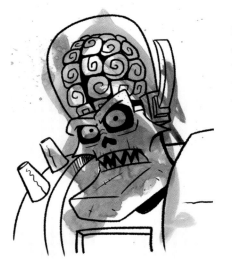

In this example I gave my two kids, ages 3 and 7, some paper and watercolor paint and let them go to town. I then had the challenge to change these paint blobs into characters.

I scanned the images into my computer. Then I drew over the images in Photoshop. I let my imagination run wild. It was exciting to see what weird things I might create.

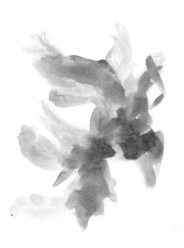

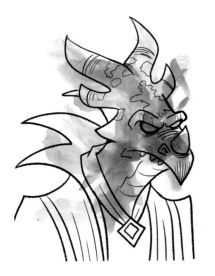

Just like seeing a dragon in the clouds I used these paint blobs to jog my mind for some creative ideas for boss-level characters. Notice, I didn't trace over the paint blob but use the organic shapes to get my mind working.

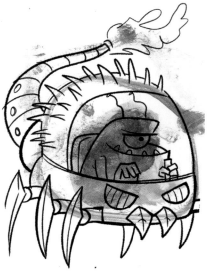

Remember, you can turn these paint blobs in different directions. Try creating more than just one character from the same blob if you like. Even if you don't end up using these paint-blobbed doodles, it's still a great way to get your brain working to come up with an idea instead of staring at a blank piece of paper and hoping something might appear.

Boss Monsters From Paint Blobs

Here's how to create a unique looking boss monster when you have absolutely no idea what to create. This is an easy way to jump start your brain into the creative process. You'll create interesting shapes and forms with paint and then turn those shapes into characters. Even when you don't feel creative it is important to make creativity happen. Looking at a blank piece of paper isn't going to make ideas magically appear. But if you start throwing down shapes and forms, your brain will start working and get excited about what creatures those forms might become.

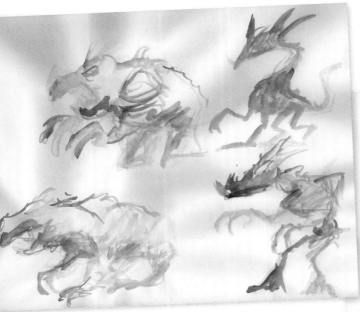

1 Using a paintbrush and some water-colors, paint some loose, fun monster shapes. Let your mind and your hand go free and see what strange shapes and paint blobs you come up with.

2 Once the watercolor blobs have dried, go over the forms with a pen and see what you can create. Don't trace exactly over the forms, but use the paint blobs as ideas to get your imagination working.

3 Pick the character you like the best for your boss character. You might think you're finished, but actually you're just getting started. Now take that character, elaborate on it and see how much better you can make it.

4 I wanted this boss character to be big, bad and menacing. Rough out a bigger, stronger body for your character.

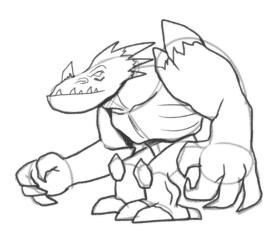

5 Now that your idea for your character is in place, draw the construction shapes for the bad boss body.

6 Once you have the body constructed, you can work on adding details and refining the form.

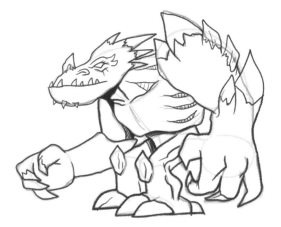

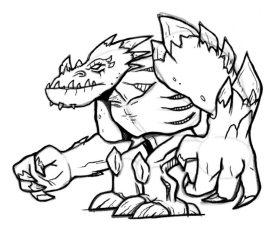

7 Keep adding details to this creature. I loved the spikes and I wondered, how many I could add before I overdid it?

8 Adding details will be even more important when you begin to ink your character. I not only added more details at this stage, but still made changes to the drawing.

Robot Monster

I liked this robot monster with a rather large brain sealed in a glass case. I liked how strange it is and I thought I could turn it into a great boss character. This follows the same process as the previous demonstration, but also makes use of Photoshop.

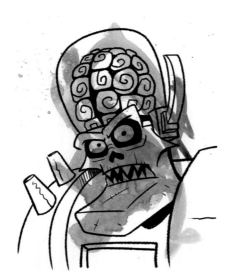

1 Break down the character's head into really basic shapes.

2 Then go back over those rough shapes and start refining the edges and the outline of the head.

3 Next add the details of the monster robot's living brain. I also added some fun shapes to the sides of the head.

4 I still made changes as I began the inking process. The one brow is slightly lowered to create more expression. I also added lots of nicks and scrapes to the metal of the robot.

112

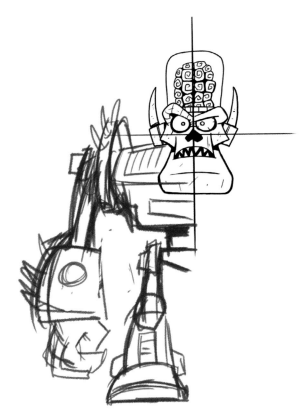

5 Using Photoshop I kept the head on one layer and then drew a very rough idea for the robot body. If you don't have Photoshop, you can use tracing paper.

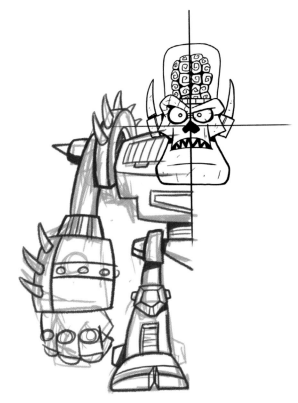

6 I focused on only half of the body, because I could copy and paste to complete the full body. Remember you can use the trick from page 34 if you're working on paper.

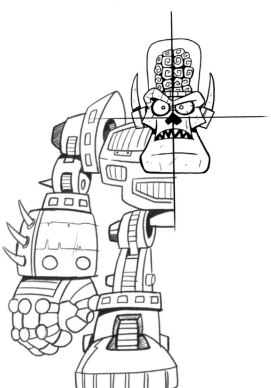

7 After refining the body over and over again, I was satisfied with this half. Working on only half of the body allowed me to go crazy with the details.

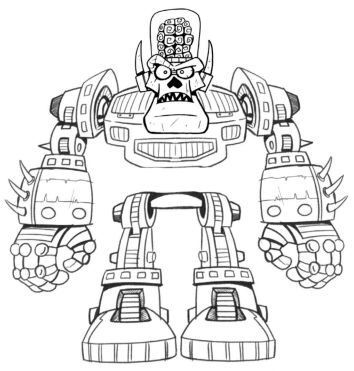

8 Now that you have finished half of the body, flip it and paste it. I wasn't happy with the shortness of the body so I cut the torso and moved it, making the character longer.

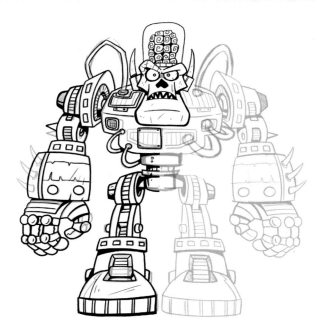

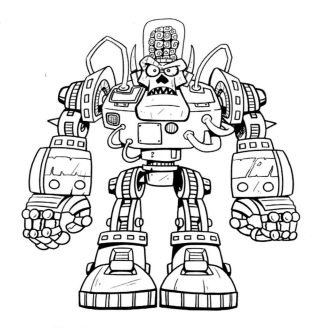

9 Once again, even as I inked this character, I made changes to it. I got rid of the spikes on the arm and opted for some really cool cables protruding from the body.

10 Now with half the body inked, copy, flip and paste. Go back and make changes to the second half of the body. Even though it is a copy, you don't want it to look exactly the same.

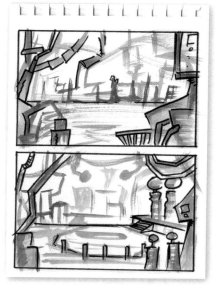

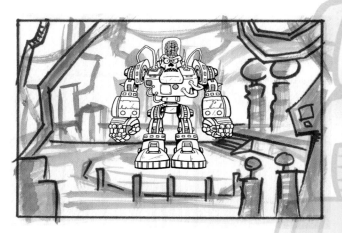

11 Use watercolor paper and rough out two possible ideas for a setting or world for this boss to reside in. I wanted something very mechanical and factory looking.

12 Scan in your rough idea and then place your robot monster inside of this very rough world so you can get a sense of scale.

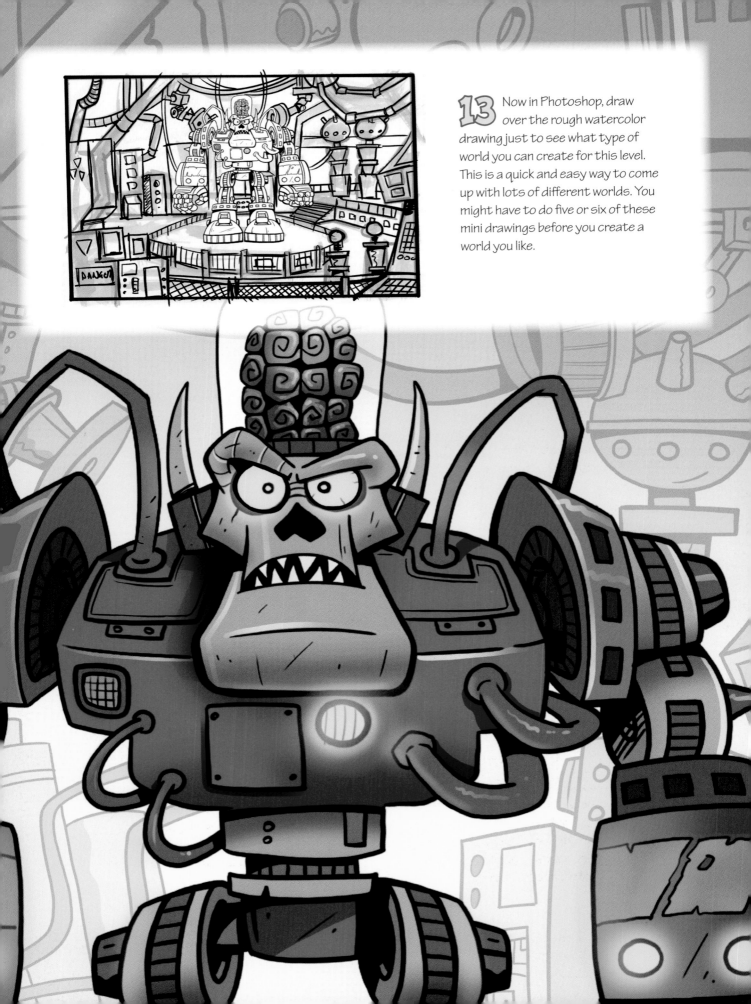

13 Now in Photoshop, draw over the rough watercolor drawing just to see what type of world you can create for this level. This is a quick and easy way to come up with lots of different worlds. You might have to do five or six of these mini drawings before you create a world you like.

Creating the Boss-Level World

You can use the same rough painting technique to come up with ideas for the world or level where the boss character will reside. It's important for the setting to be just as intimidating as the boss.

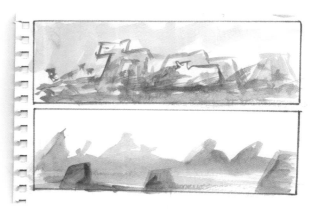

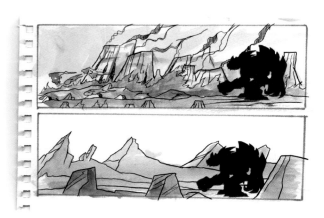

I painted some rough ideas on watercolor paper, just loose and simple shapes. I then scanned these images into Photoshop and placed a silhouette of the monster into each scene so I could have an idea of scale.

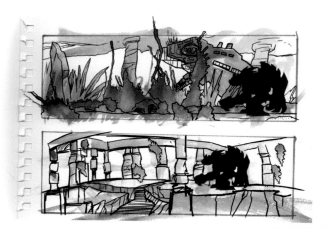

In the top painting I used a compressed air canister on the wet paint to create the twisted, alien-looking shapes. When I went over these shapes with ink, they look like alien rock formations or an ocean coral. Each scene has its own unique feel and environment.

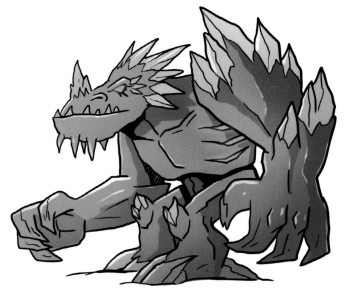

Keep in mind that your character should have something in common with its environment or the world that it lives in. If your monster lives in a frozen world, it might take on features of that frozen world.

If your creature lives on some alien world, it might take on the colors of that planet. Is the coloring of your creature used to camouflage it or to warn others to stay away?

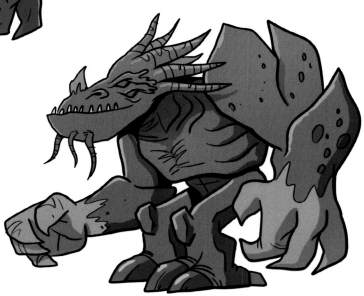

Keep in mind that the boss character and its world should be memorable. Make the player feel that this character really could exist in the world you create for your boss-level creature.

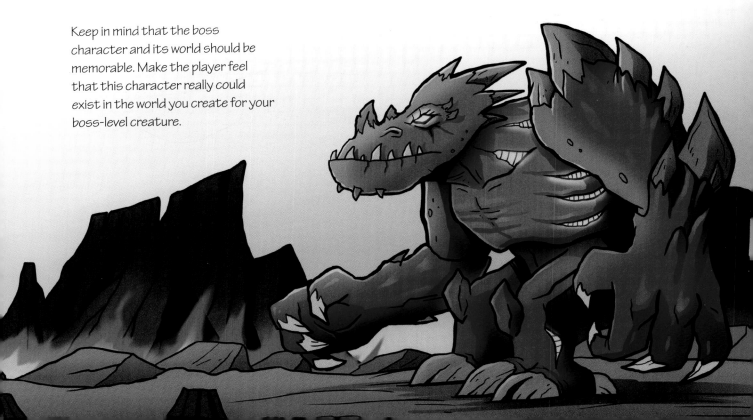

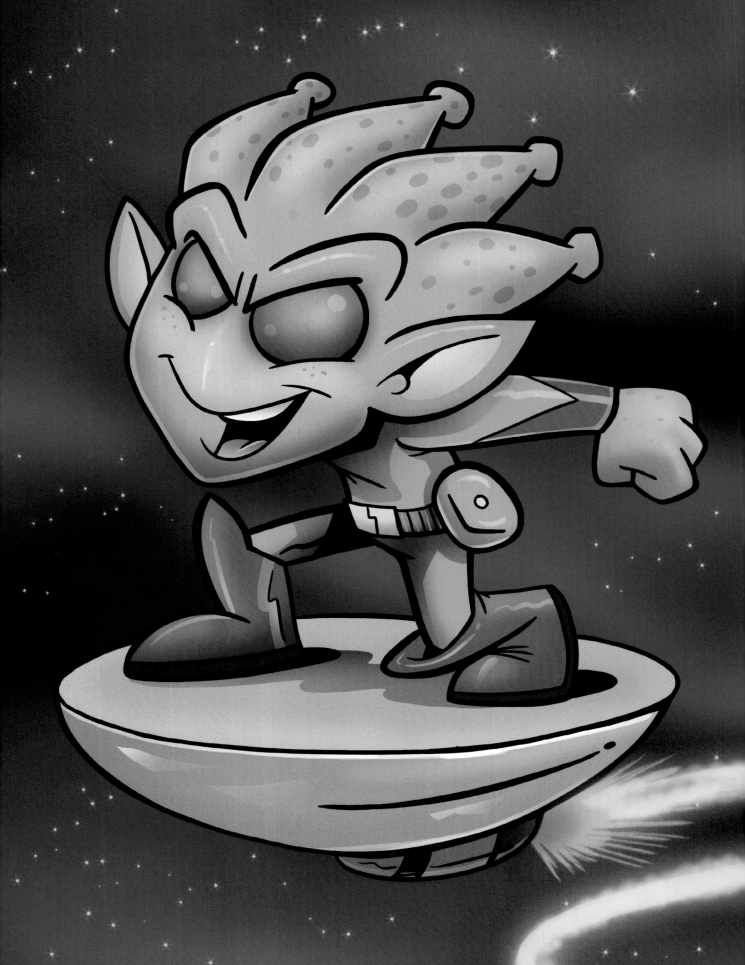

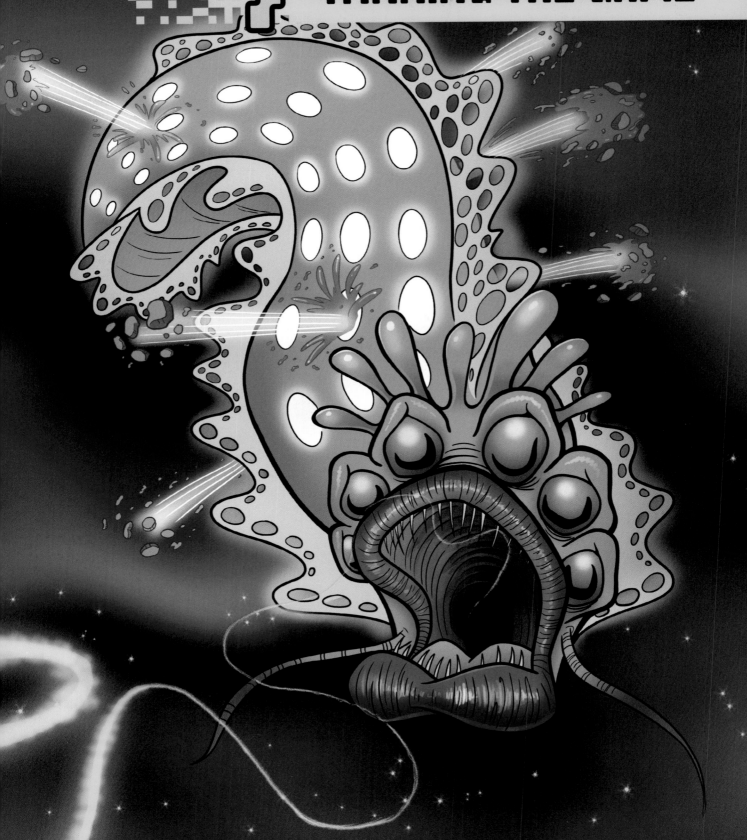

Hey drawing fans,

We are at the last chapter of our book Awwww, don't be sad! The ending is always the best part of any movie, book or video game. That's right. It's time to create a huge visual payoff for the end of our video game. We need to create a scene that makes winning the game feel like it was completely worth all those finger blisters, rage quits, and finally winning all those worlds and levels. To create the end we are going to learn the art of the storyboard. Simply put, it's a visual way to tell a story, sort of like a comic book. The only difference is that your storyboard doesn't need to be polished or look exceptionally good. The storyboard should be a very quick and easy way to show how the animation or movie will play. A storyboard can also be used to introduce the beginning of the game, or for cutscenes to help advance the story.

Creating the Storyboard

To create the storyboard we need to think about our characters as if they are in a movie. We want the movie to have an emotional impact on our audience or gamer. Planning your storyboard should be fun and exciting because you really don't need great art; simple doodles will work just fine for this project.

Have I mentioned sticky notes yet? Yes, I guess probably a hundred times already. The great thing about using sticky notes for a storyboard is they can easily be rearranged or more can be added in your storyboard if needed.

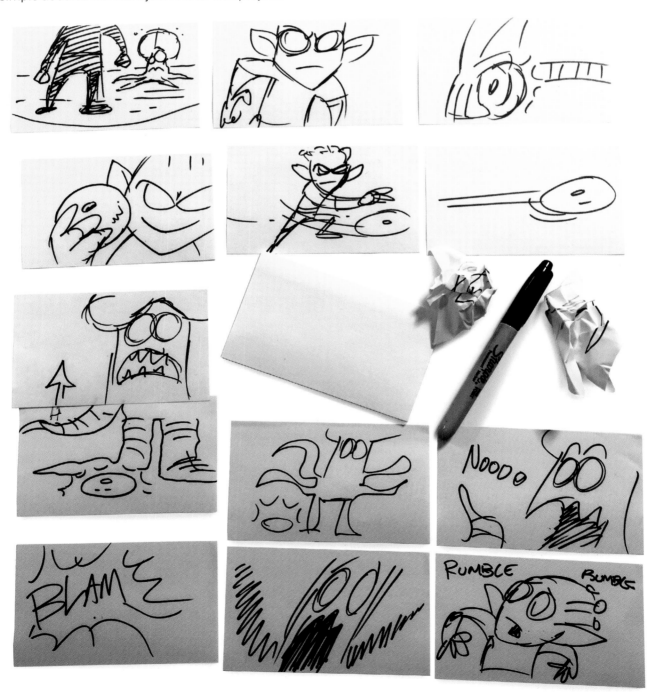

You Are the Director

Think of yourself as a movie director. In this movie clip we need our alien friend, Zumona, to quickly get out of harm's way as the giant planet-eating slug explodes from the inside out. We want the pace to be fast, and we want the gamer to feel like they are in the action.

Let's talk camera shots. Camera shots will help make the scene more interesting and make the audience feel like part of the action. Different camera angles can also create a mood for your scene or be used to break up a scene to create more visual interest. Below are a few samples of different camera angles. Try using these different shots in your storyboard.

Extreme Close-Up–Used to show a character's thoughts or emotions.

Establishing Shot–Shows the setting where the story takes place.

Over the Shoulder–A clever way to show both characters in a scene.

High-Angle Shot–Makes the character look small or helpless when facing an enemy.

Long Shot–Used to show size of the characters in relation to one another or to the setting.

Tracking Shot–Camera follows the character as they move through the scene.

Notice the variety of shots used in the first three panels. They each have a different camera angle starting with an over-the-shoulder shot, followed by a medium shot, and last an extreme close-up shot of the disc bomb being removed from the alien's belt. As you look through this storyboard, see if you can spot the different camera shots used.

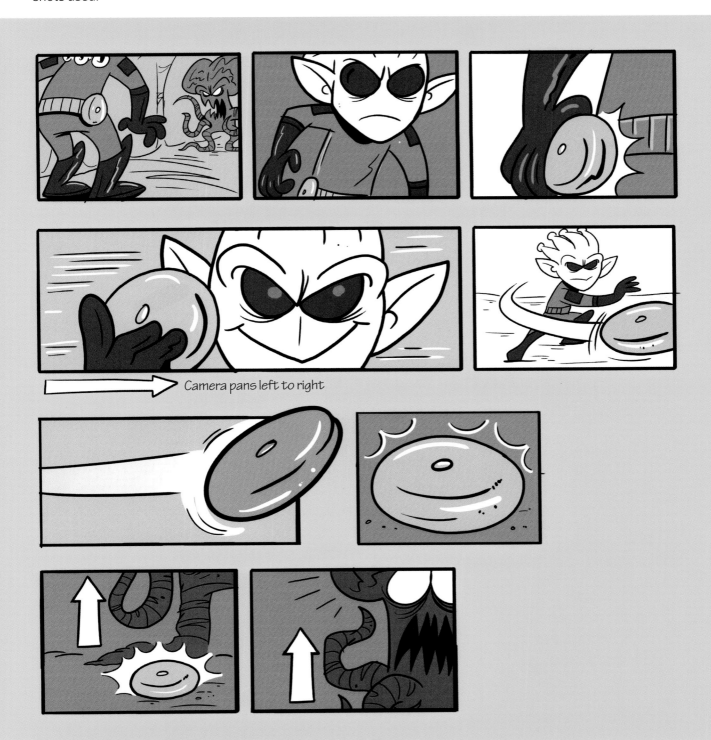

Camera pans left to right

This is a quick sample storyboard for the end of a video game. I tried to keep it exciting and fast moving. Using lots of camera shots allows the audience to really feel like they are a part of the story. Your story might have dialogue, or characters talking to one another, and that can be added to your storyboard, too. While watching movies and reading comic books, study the camera shots and think about why the director or artist used them.

Consider what type of special effects will happen in the scene.

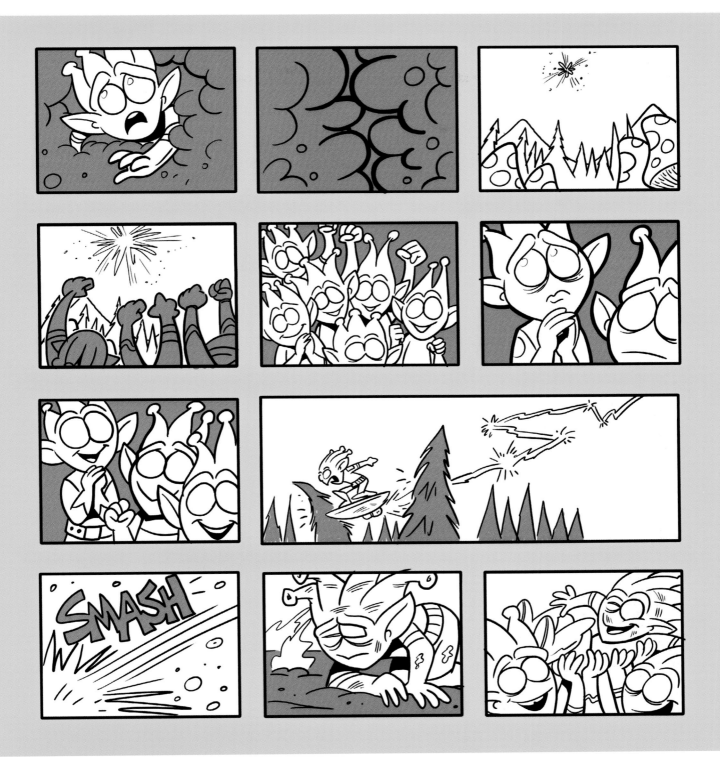

So here it is, friends, the end of this book. The end of the book is not the end of the game! No, the game is just beginning for you and what an exciting game it is! A game you are going to create, a game you are going to imagine as you fill sketchbooks with ideas and drawings. You now have the tools to get your ideas on paper and make all kinds of worlds, creatures and stories. These skills can be used to design games, illustrate books or create your own line of clothing or action figures. So this book isn't going to end with the line "Game Over." Instead it will end with the word *start*.

Index

a content + ecommerce company

21 20 19 18 5 4 3

DISTRIBUTED IN THE U.K. AND EUROPE
BY F&W MEDIA INTERNATIONAL LTD
Pynes Hill Court, Pynes Hill, Rydon Lane, Exeter, EX2 5AZ,
United Kingdom
Tel: (+44) 1392 79680
Email: enquiries@fwmedia.com

ISBN 13: 978-1-4403-5185-3

Edited by Amy Jones
Designed by Clare Finney
Production coordinated by Jennifer Bass

About the Author

Steve Harpster has authored and illustrated more than ninety books for children, and his artwork can be found on a variety of products such as T-shirts, stickers, toys and games. In 2010 Harpster created a company called Harptoons with the goal of getting children to draw, create and imagine. Through his books, videos and school visits Harpster hopes to encourage children to create their own books, characters, worlds and video games.

Harpster resides in Cincinnati, Ohio, with his wife and two sons, Tyler and Cooper. When Harpster isn't busy drawing or visiting schools, he likes to watch movies, play with his kids and ride roller coasters. His favorite foods are pizza and burgers, and his favorite dessert is ice cream or anything chocolate.

See more of Harpster's work at Harptoons.com or at his Facebook page, Harptoons Publishing.

Watch Harpster's how-to-draw videos on YouTube at Steve Harpster or Harptoons.

Acknowledgments

I would like to thank Steve Barr for introducing me to the wonderful staff and editors at IMPACT Books. His praise for my work has been wonderful and greatly appreciated. I would also like to thank the countless number of children who write to me, send me art, watch my videos and draw with me. Without these young artists none of this would have happened. To my son Tyler, who offered to stay late at school one afternoon so I could finish this book, his help and approval on many of the chapters was greatly appreciated. I want to thank Cooper for the countless game breaks he offered and sometimes demanded that I take. The most important person who helped make this book possible is my amazing wife, Karen. She was always encouraging and knew that I would finish this book, even when I was doubting it.
Thanks, Boo.

Metric Conversion Chart

To convert	to	multiply by
Inches	Centimeters	2.54
Centimeters	Inches	0.4
Feet	Centimeters	30.5
Centimeters	Feet	0.03
Yards	Meters	0.9
Meters	Yards	1.1

Ideas. Instruction. Inspiration.

Download FREE demonstrations at impact-books.com.

Check out these IMPACT titles at impact-books.com!

These and other fine IMPACT products are available at your local art & craft retailer, bookstore or online supplier. Visit our website at impact-books.com.

Follow IMPACT for the latest news, free wallpapers, free demos and chances to win FREE BOOKS!

 Follow us!

IMPACT-BOOKS.COM

- Connect with your favorite artists
- Get the latest in comic, fantasy and sci-fi art instruction, tips and techniques
- Be the first to get special deals on the products you need to improve your art